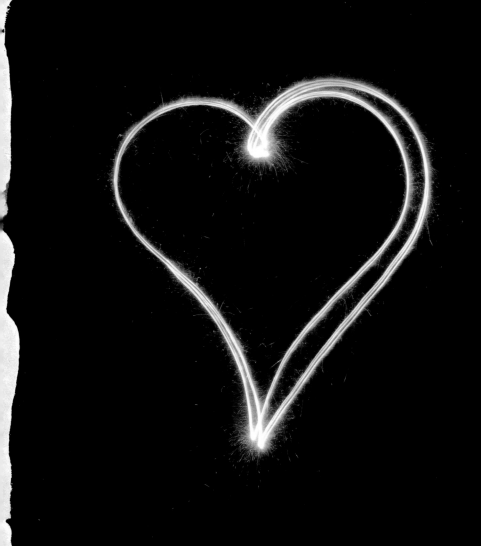

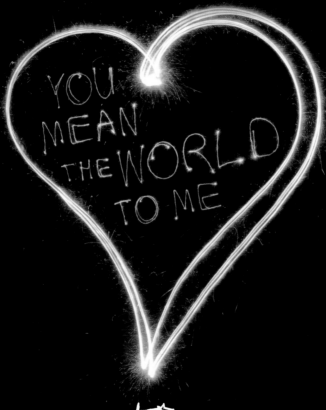

JESSE
HUNTER

YOU
MEAN
THE WORLD
TO ME

hardie grant books
MELBOURNE · LONDON

Published in 2015 by Hardie Grant Books

Hardie Grant Books (Australia)
Ground Floor, Building 1
658 Church Street
Richmond, Victoria 3121
www.hardiegrant.com.au

Hardie Grant Books (UK)
5th & 6th Floor
52-54 Southwark Street
London SE1 1RU
www.hardiegrant.co.uk

Cataloguing-in-Publication data is available from the National Library of Australia.

You Mean the World to Me
ISBN: 9781742709956

Concept, design and photography: Jesse Hunter
Design liaison: Mikala Robinson-Koss

www.alltheloveintheworld.co
@jessehunter_author (Instagram)
facebook.com/alltheloveintheworldthebook

Colour reproduction by Splitting Image Colour Studio
Printed in China by 1010 Printing International Limited

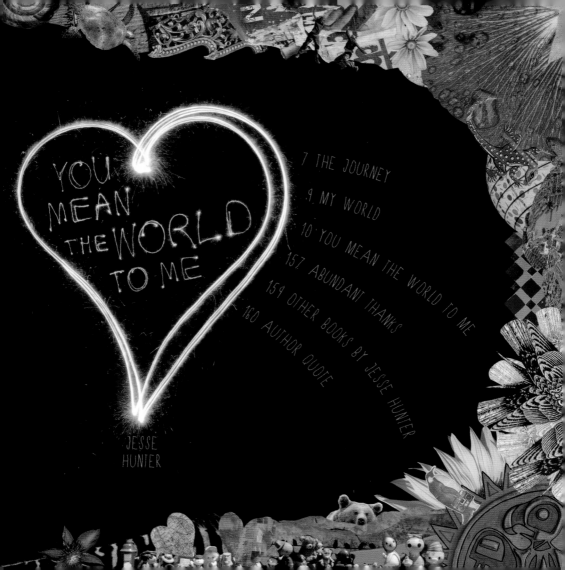

YOU MEAN THE WORLD TO ME

JESSE HUNTER

7 THE JOURNEY

9 MY WORLD

10 YOU MEAN THE WORLD TO ME

157 ABUNDANT THANKS

159 OTHER BOOKS BY JESSE HUNTER

160 AUTHOR QUOTE

THE JOURNEY

I HAVE TRAVELLED THROUGH 49 COUNTRIES
IN MY 33 YEARS ON THIS BEAUTIFUL PLANET OF OURS
AND DISCOVERED THAT EVERY SINGLE HUMAN BEING
JUST WANTS TO BE LOVED.

NO MATTER YOUR RACE, SEX, AGE, RELIGION
OR SOCIAL STATUS YOU MEAN THE WORLD TO SOMEONE
AND SOMEONE MEANS THE WORLD TO YOU.

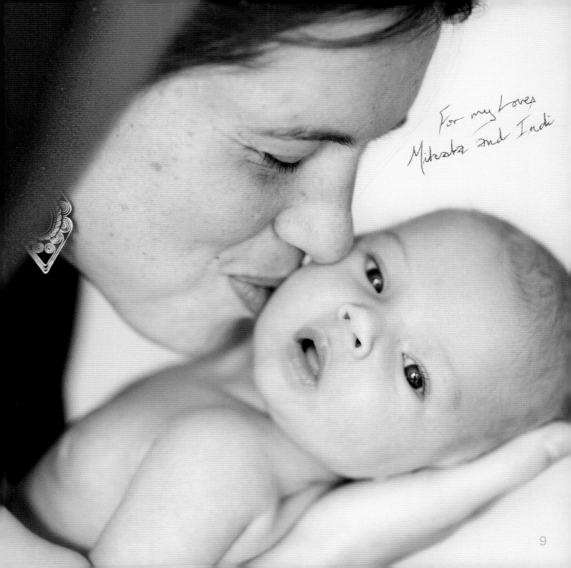

For my Loves
Mikaela and Indi

9

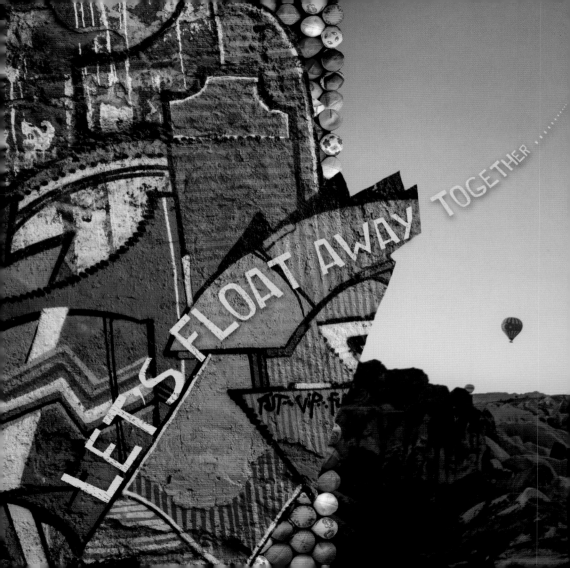

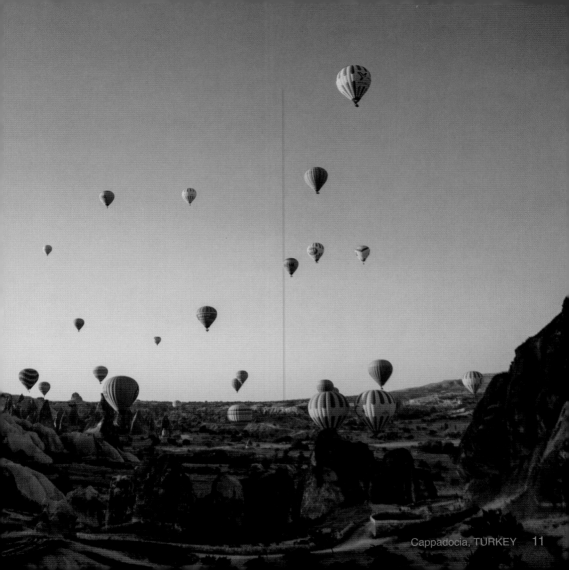

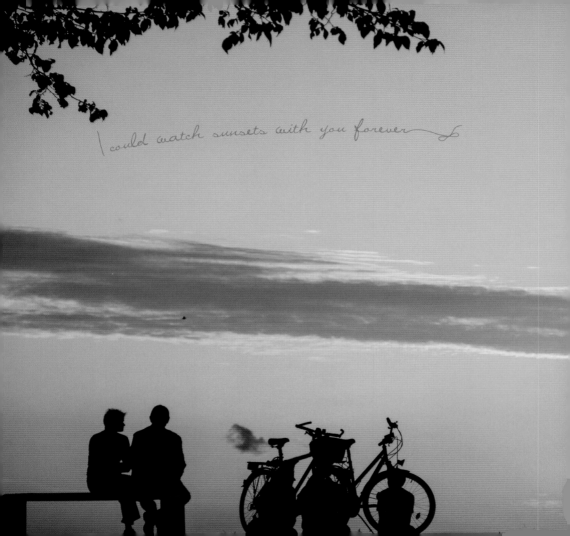

I could watch sunsets with you forever

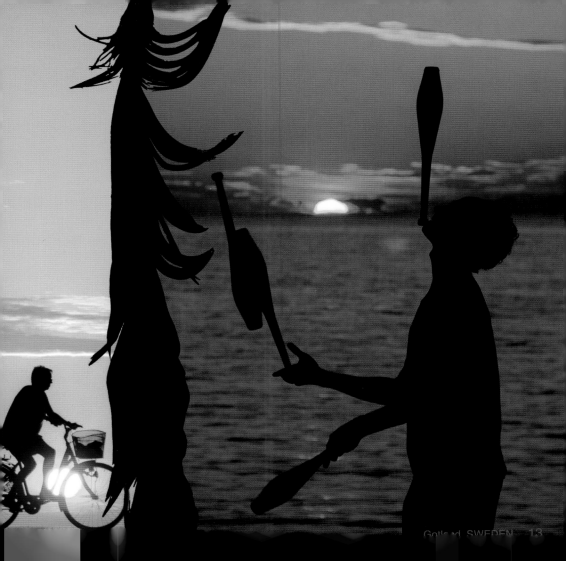
Gotland SWEDEN 13

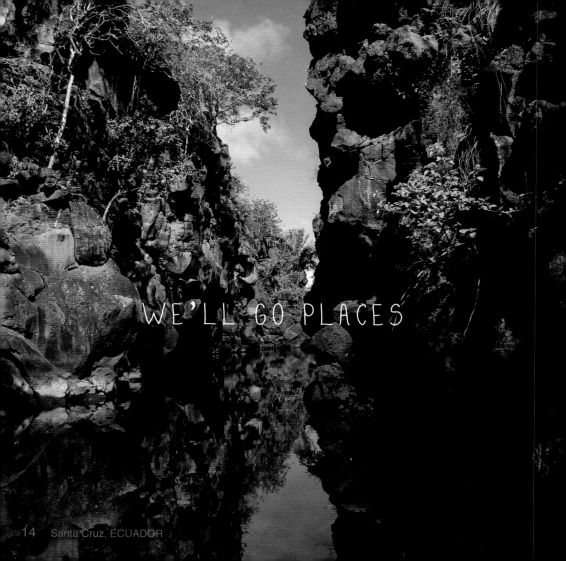

WE'LL GO PLACES

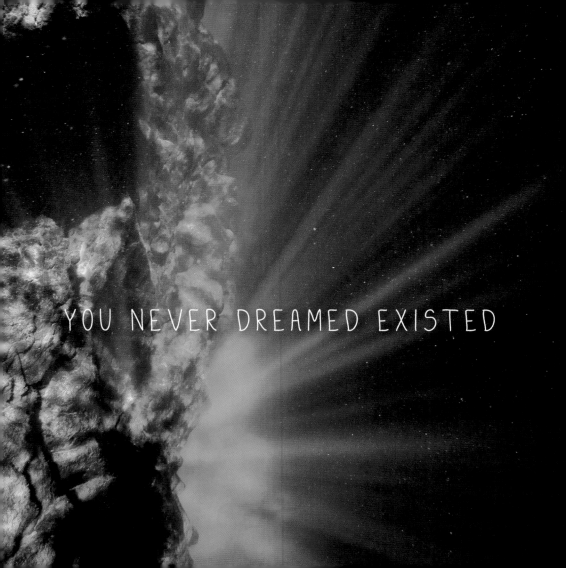
YOU NEVER DREAMED EXISTED

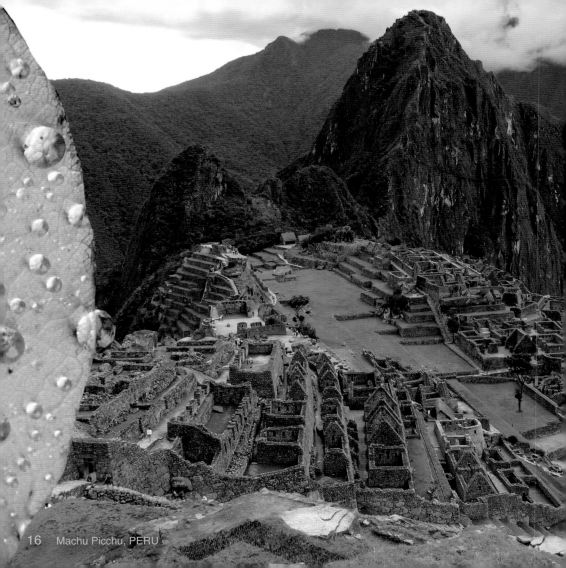

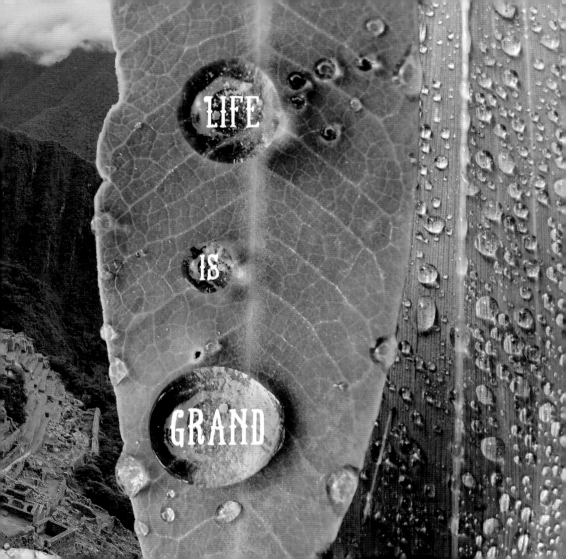

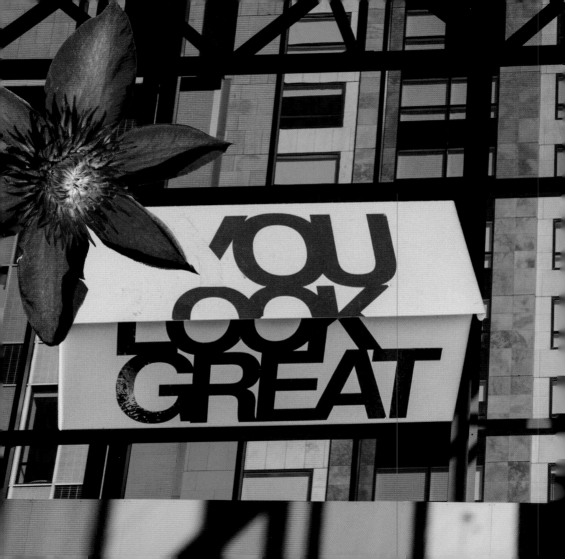

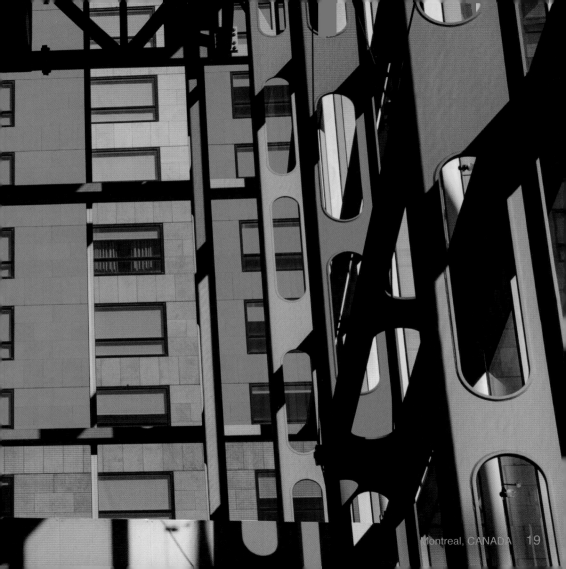

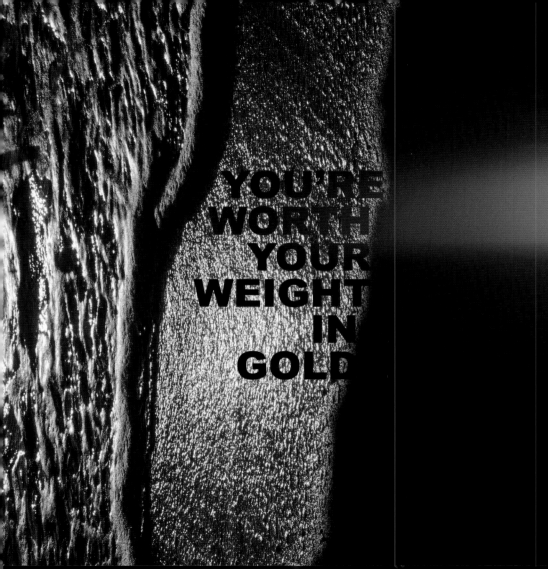

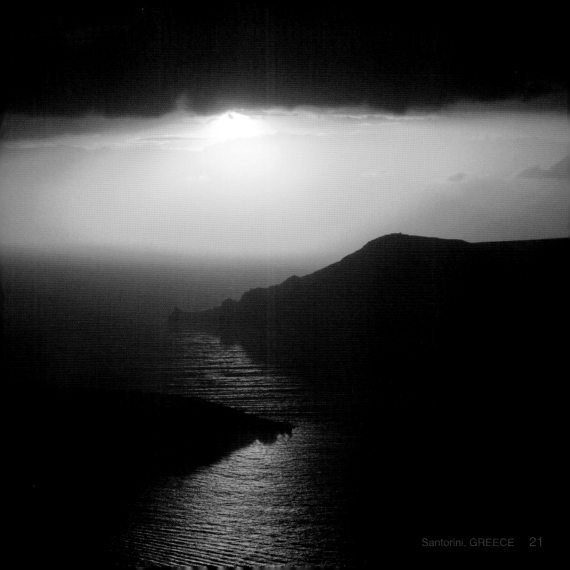

Santorini, GREECE 21

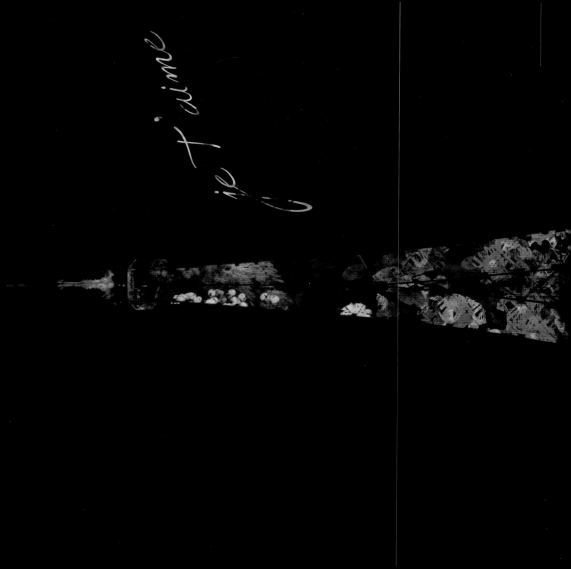

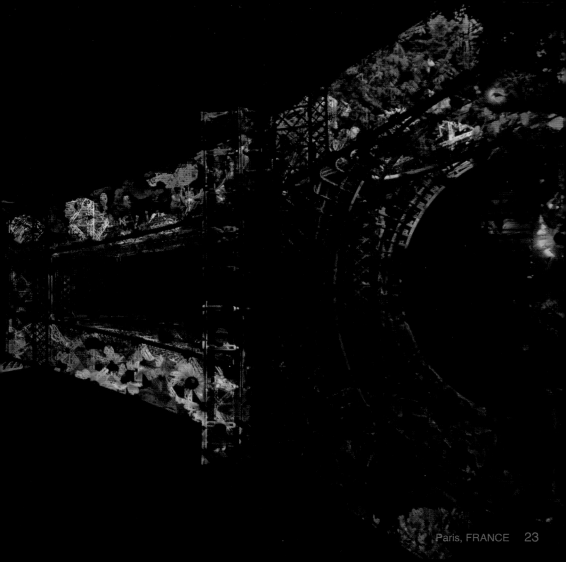

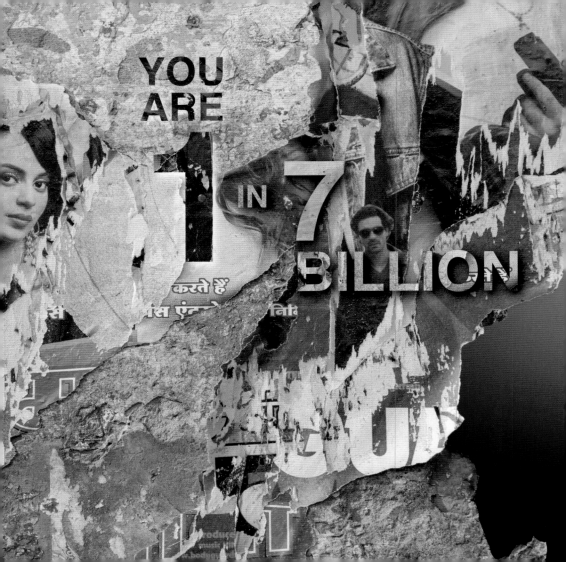

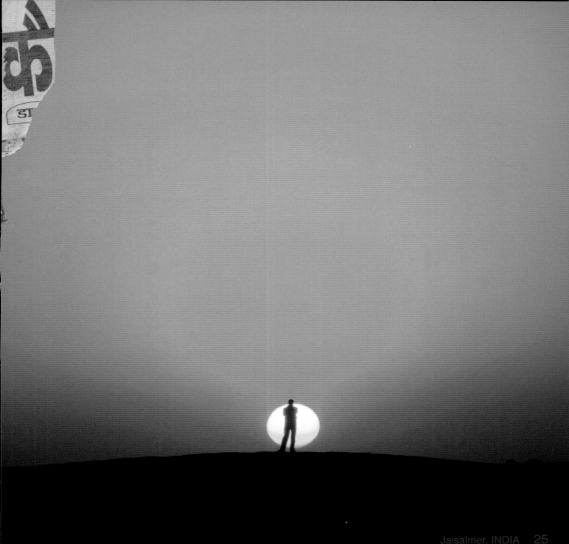

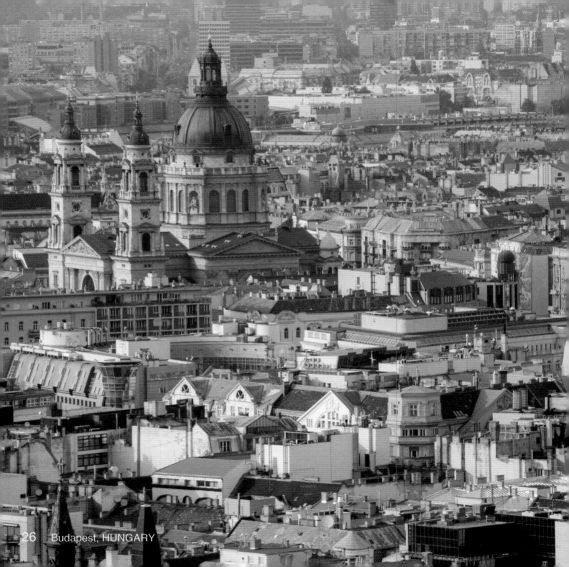

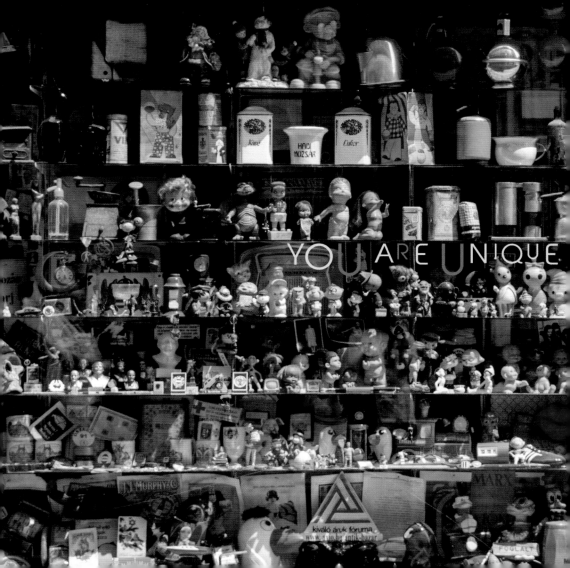

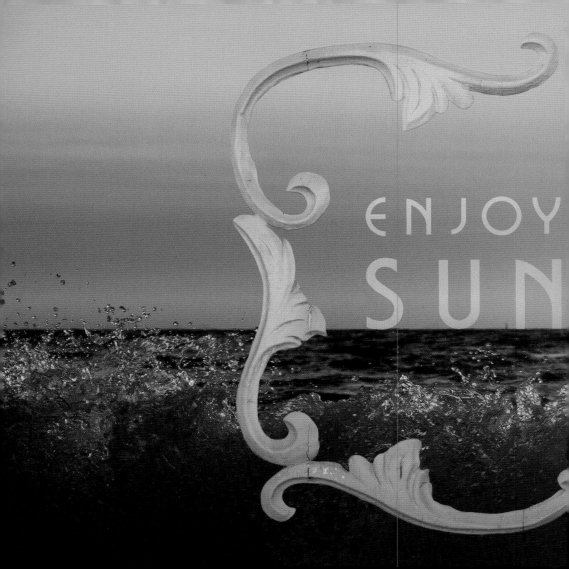

EVERY

SET

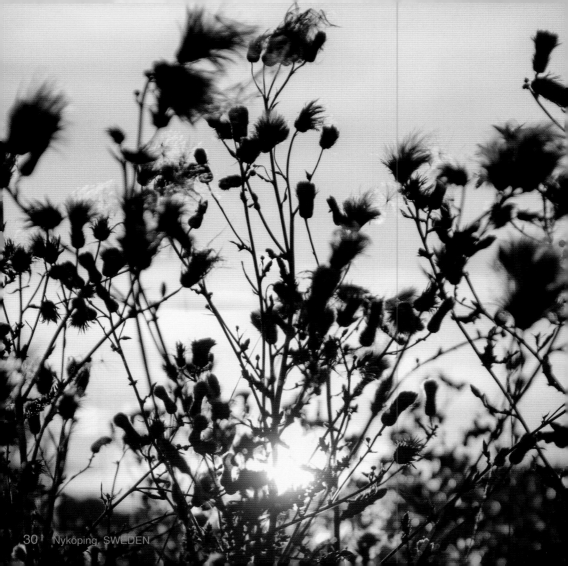

SHINE

BRIGHT

LIKE A

DIAMOND

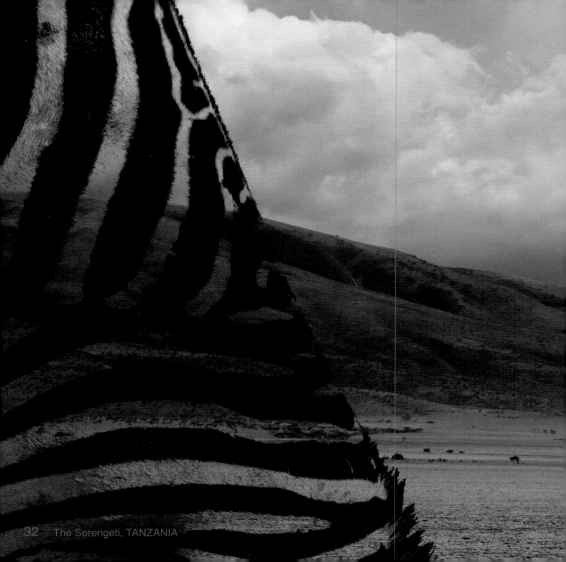

The Serengeti, TANZANIA

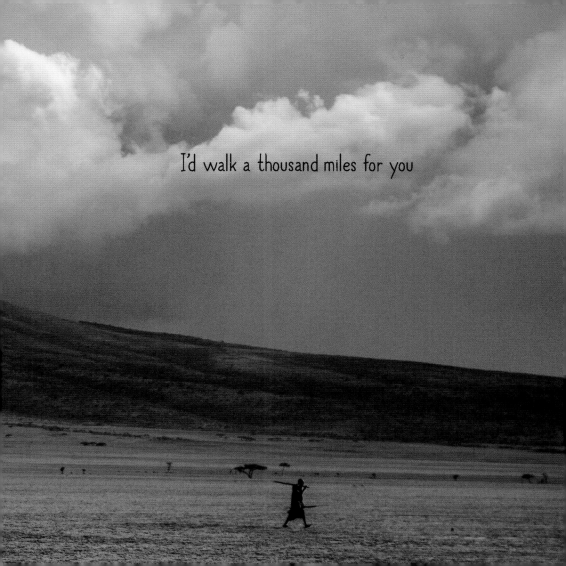

I'd walk a thousand miles for you

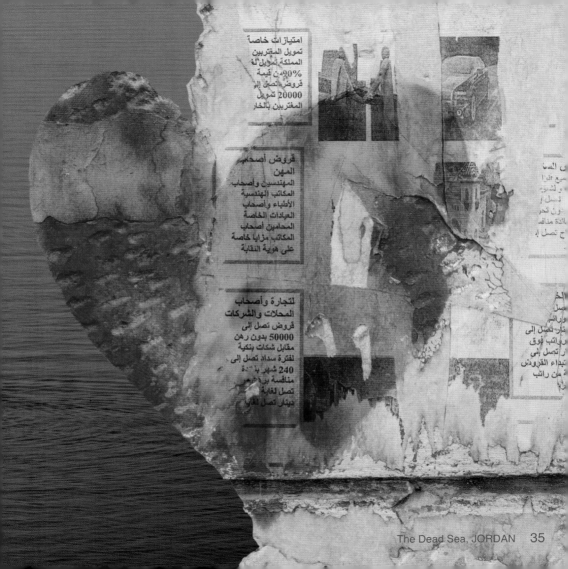

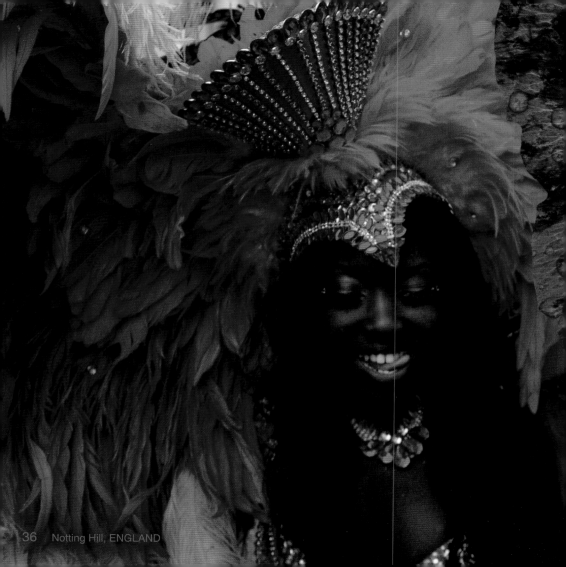

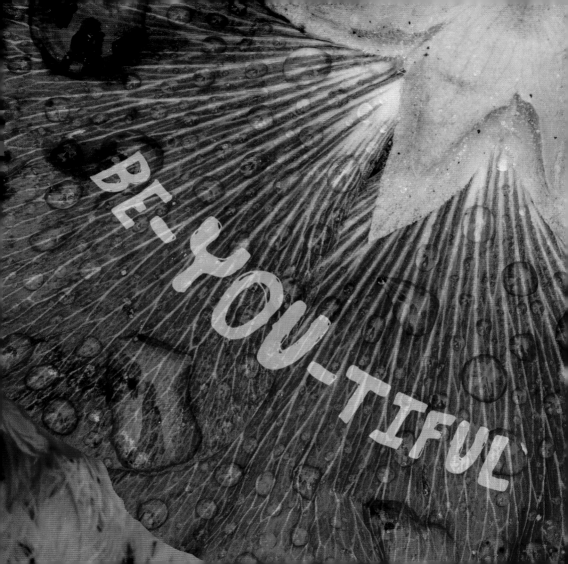

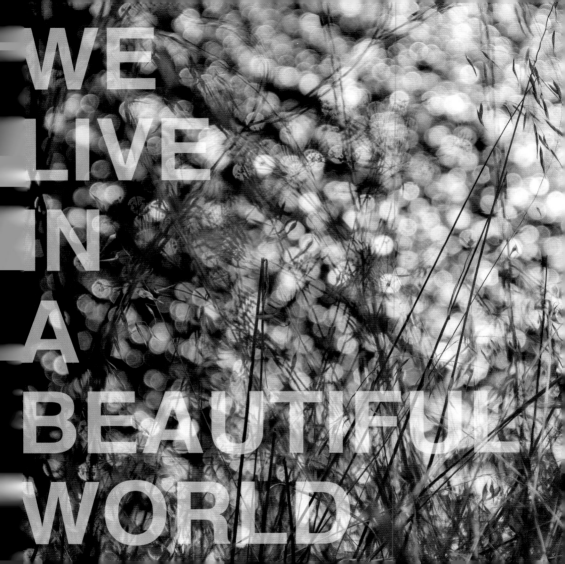

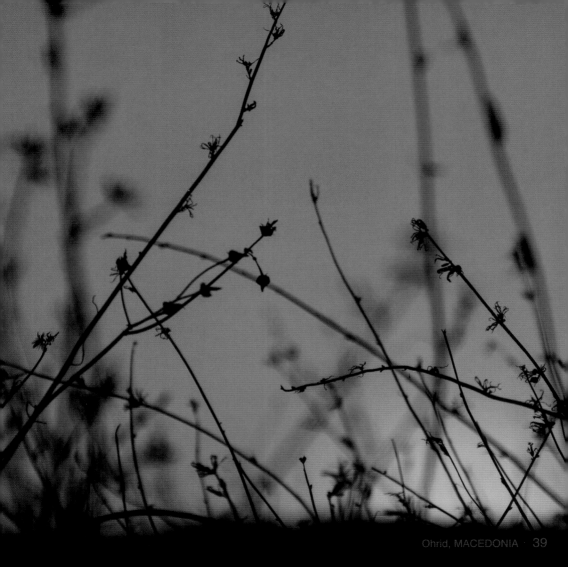

You stand
out from the crowd

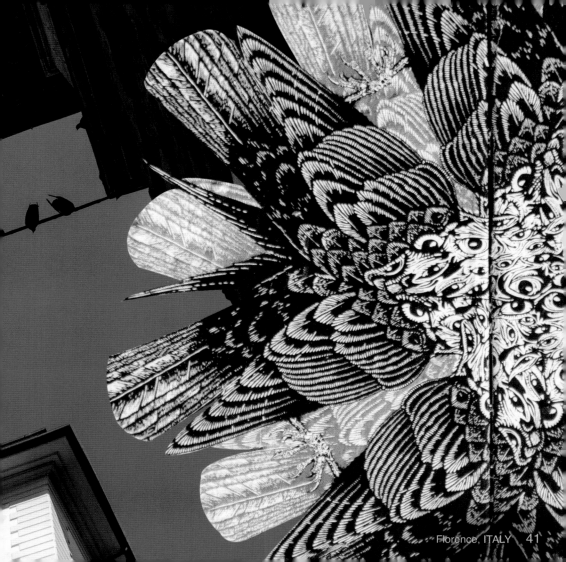

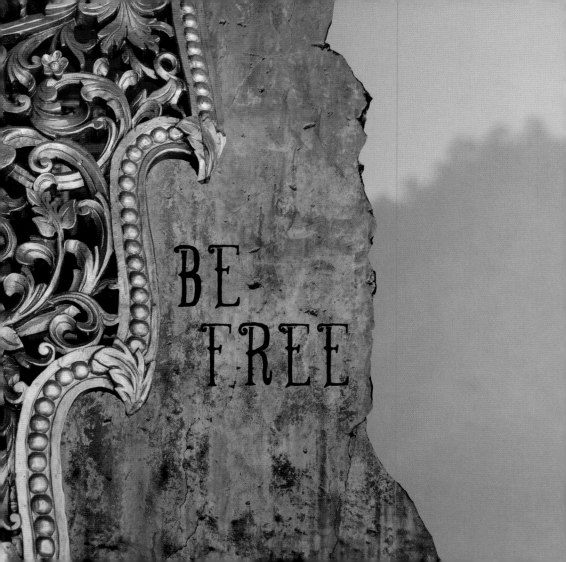

BE
FREE

Inie Lake, BURMA 43

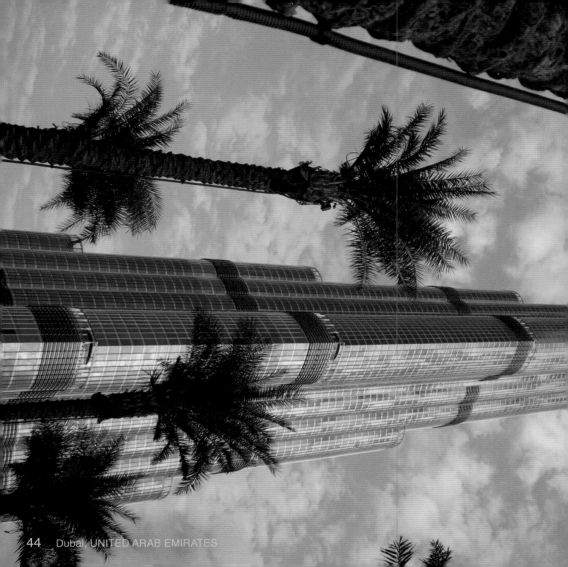

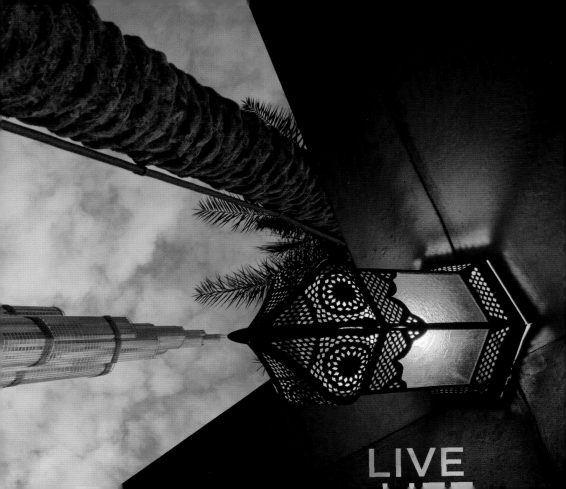

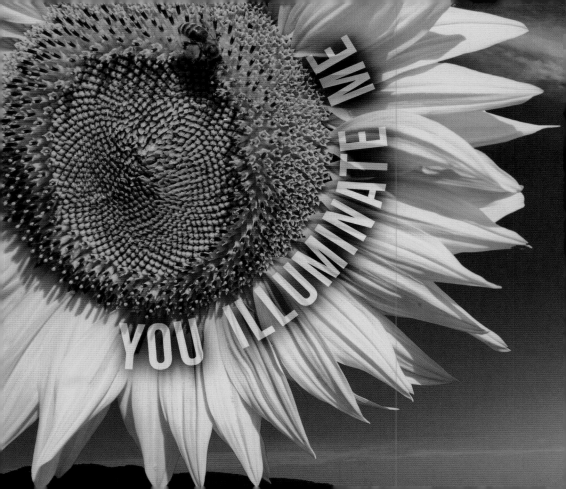

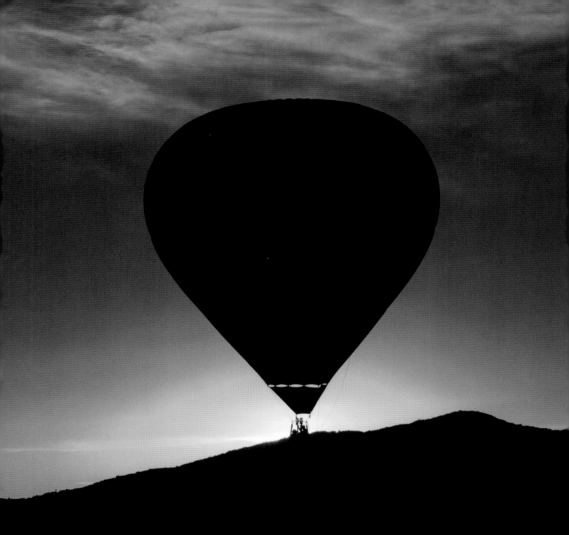

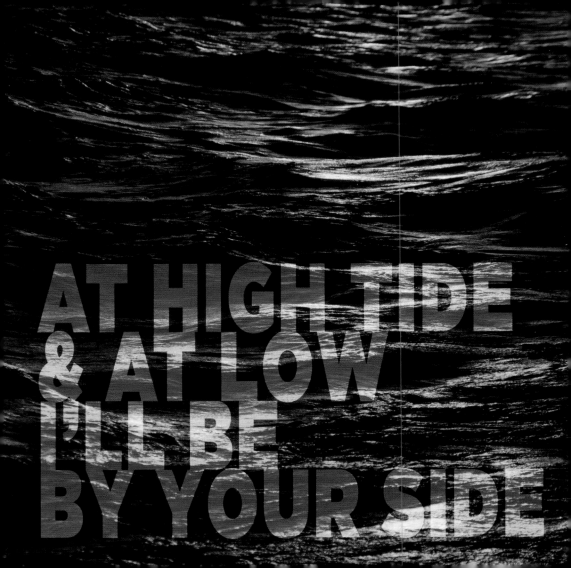

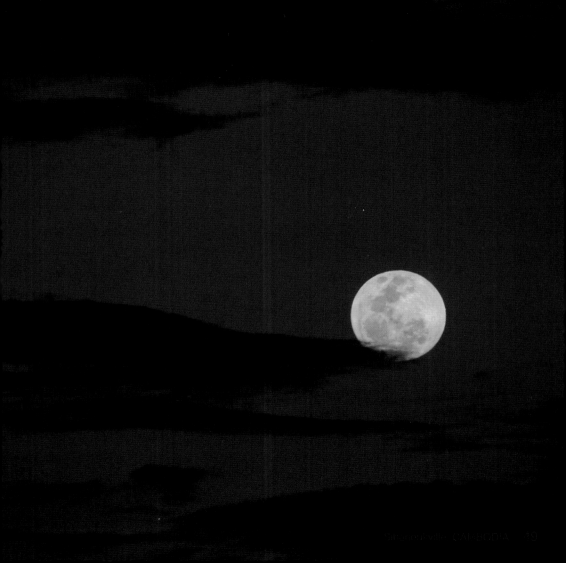
Sihanoukville CAMBODIA 49

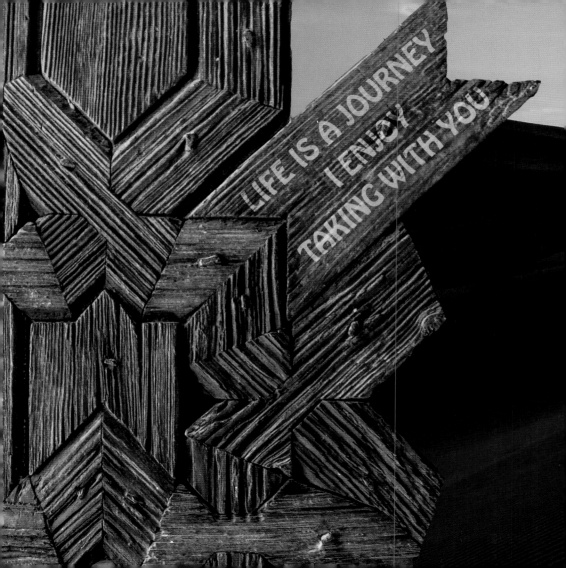

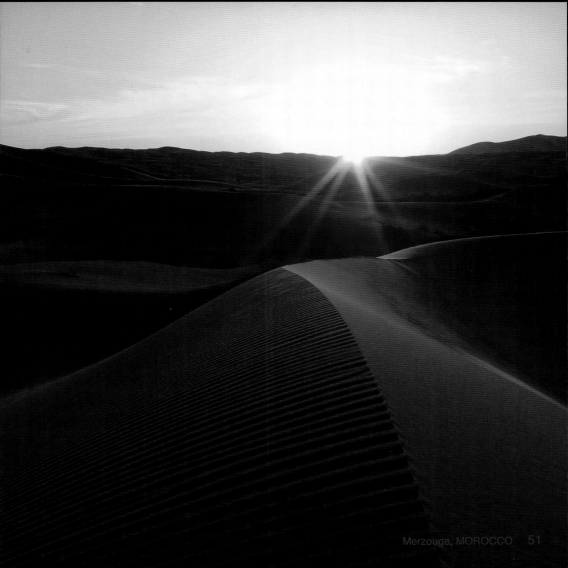

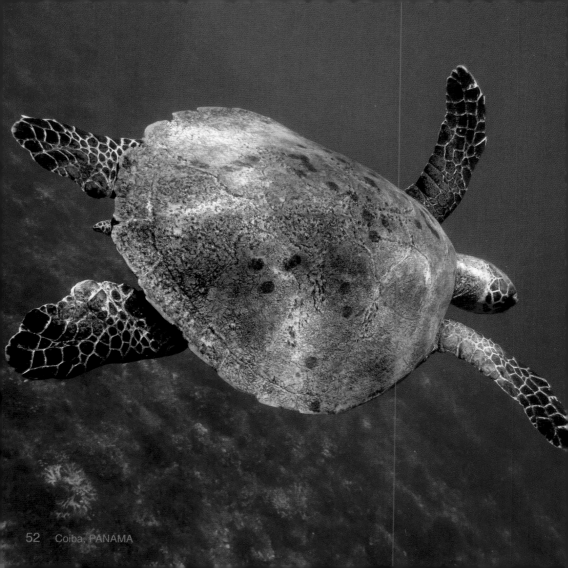

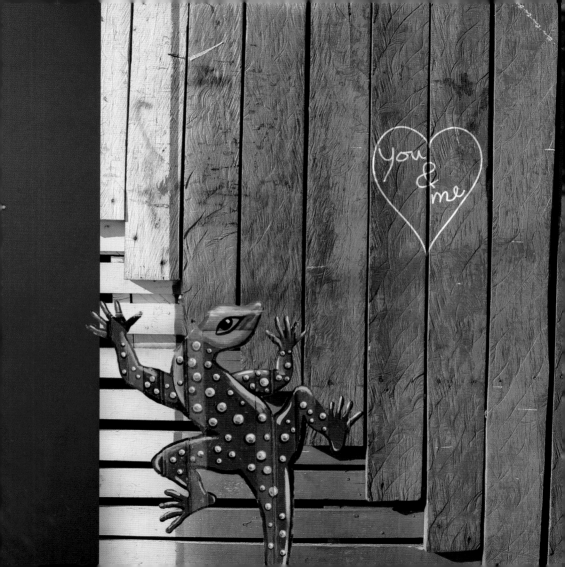

DREAMING OF AN ENDLESS SUMMER WITH YOU

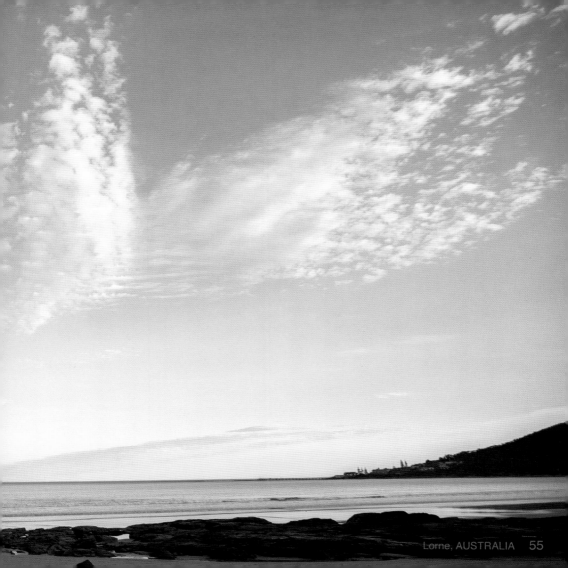

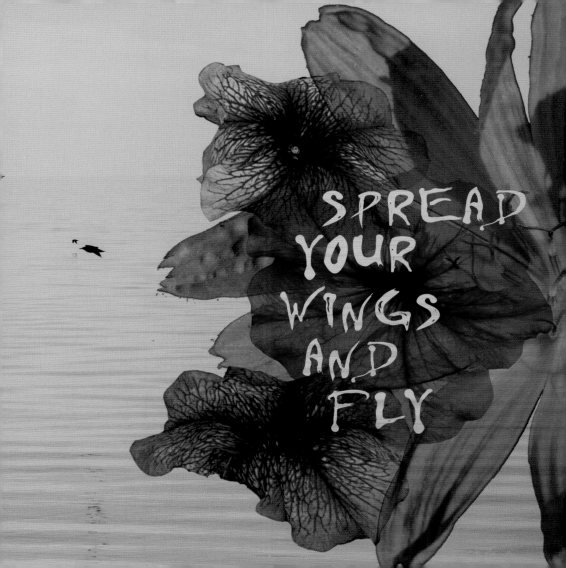

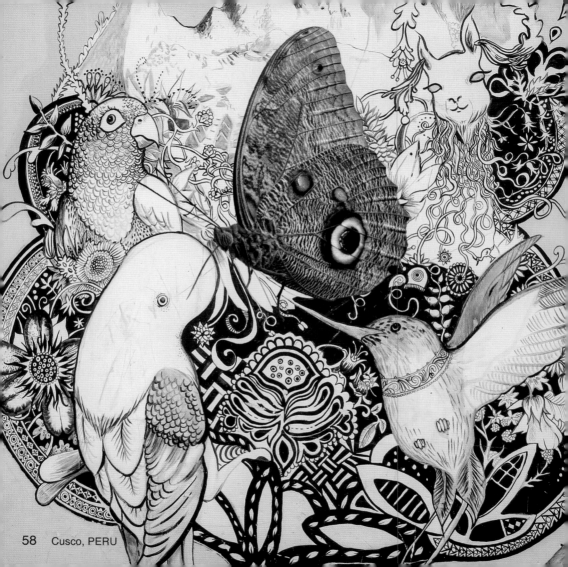

58 Cusco, PERU

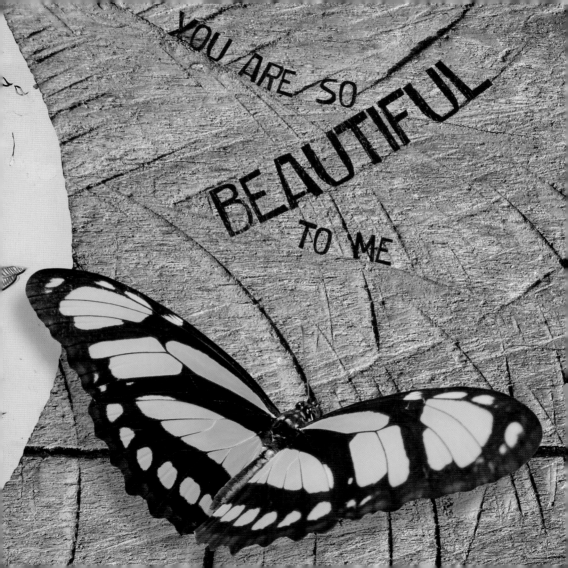

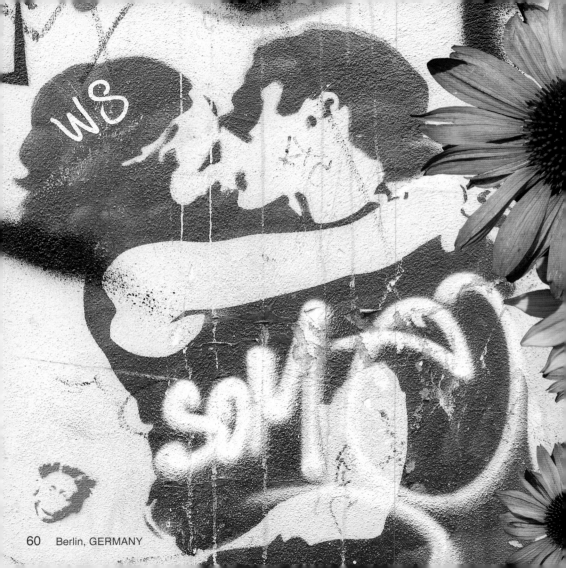

60 Berlin, GERMANY

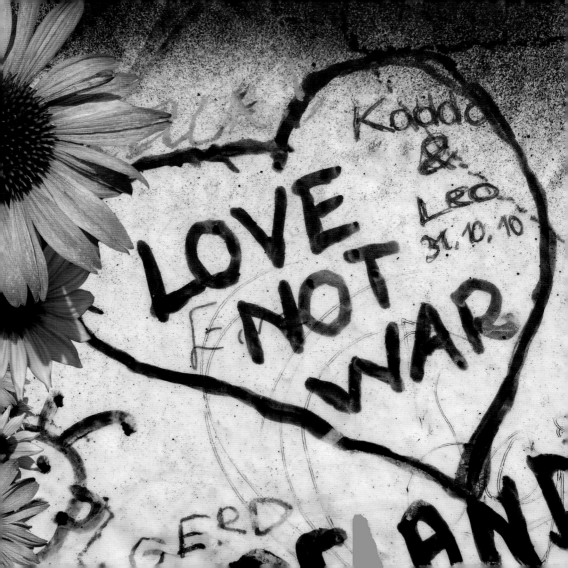

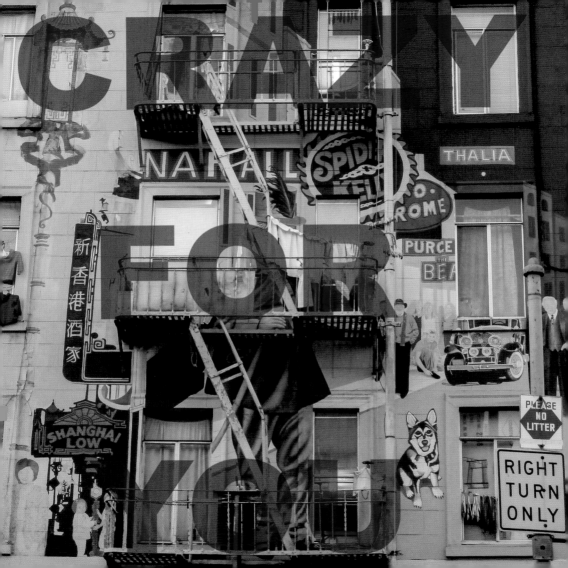

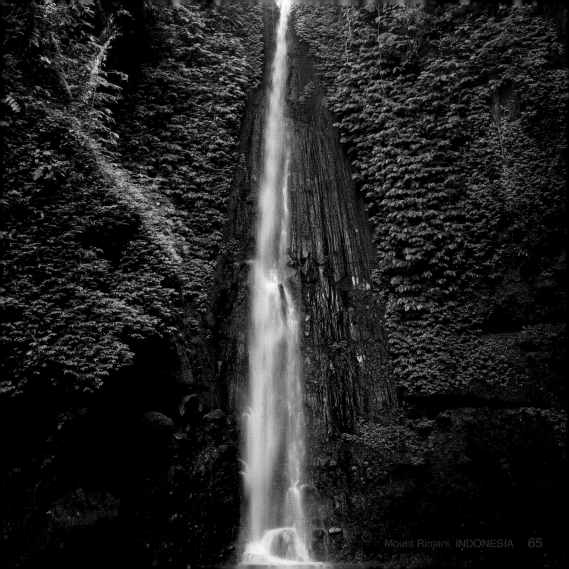

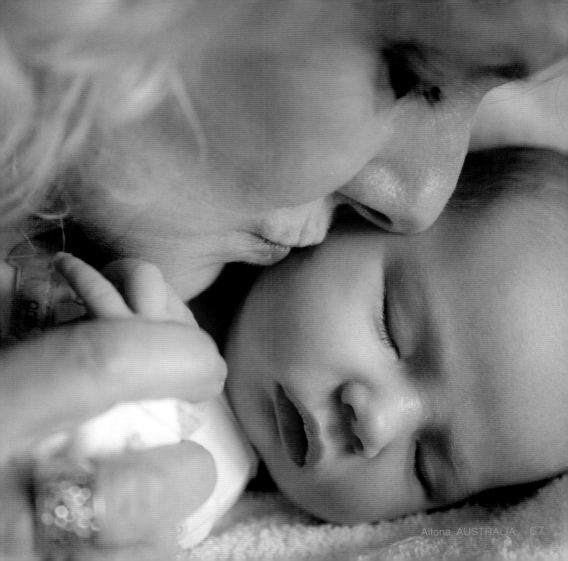

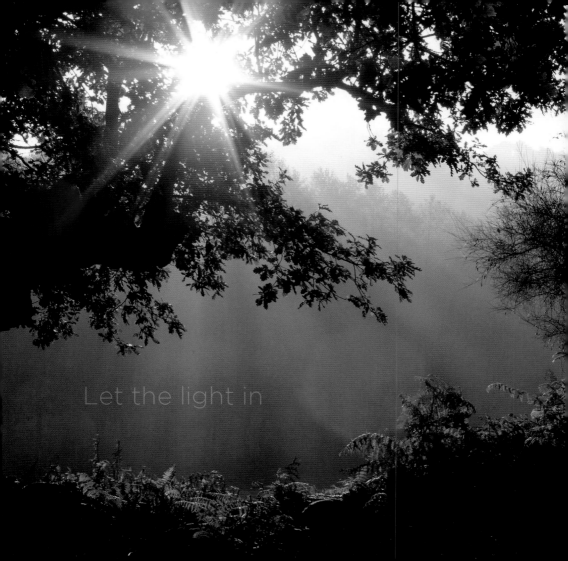

Let the light in

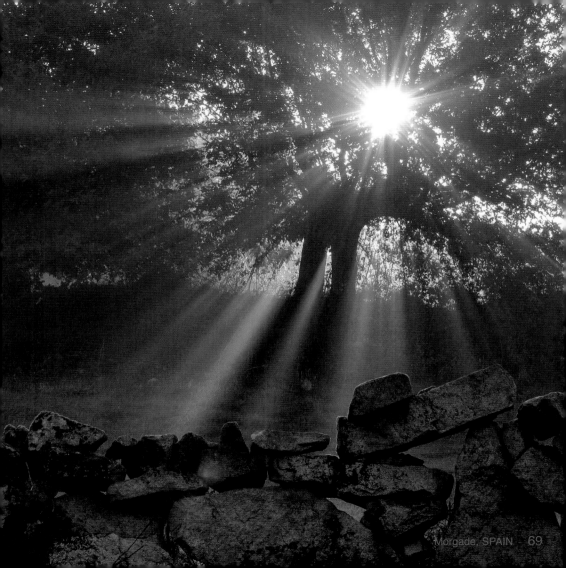

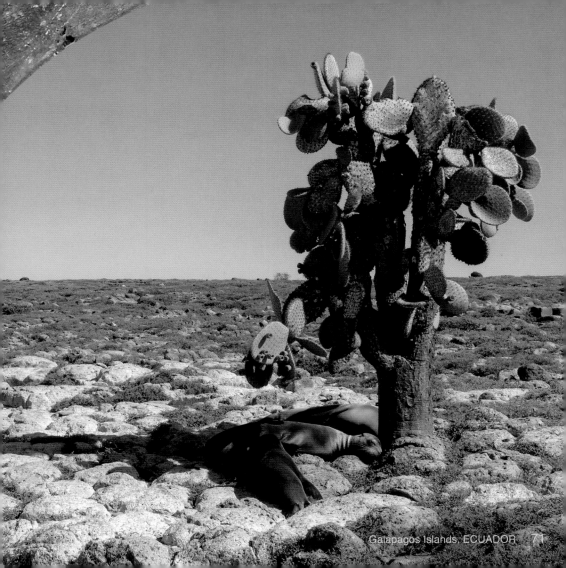

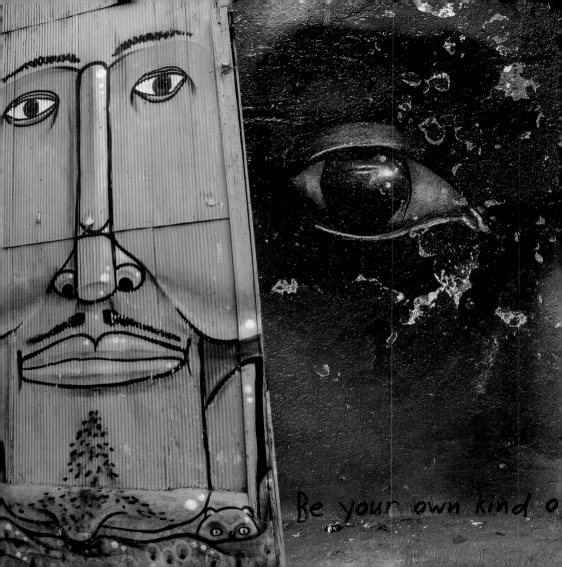

Be your own kind o

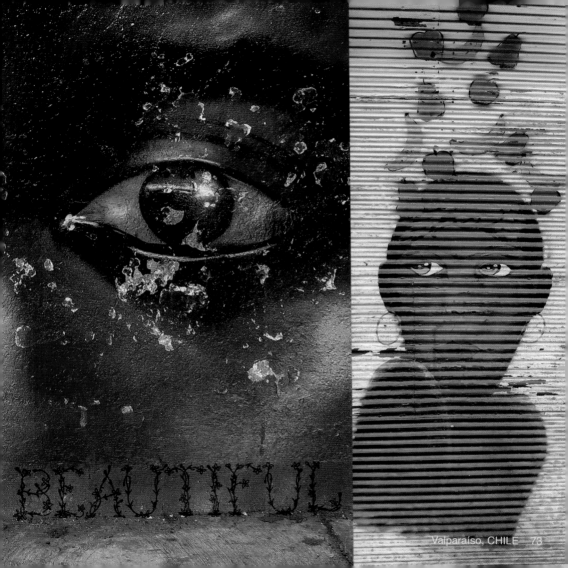

BEAUTIFUL

Valparaíso, CHILE 73

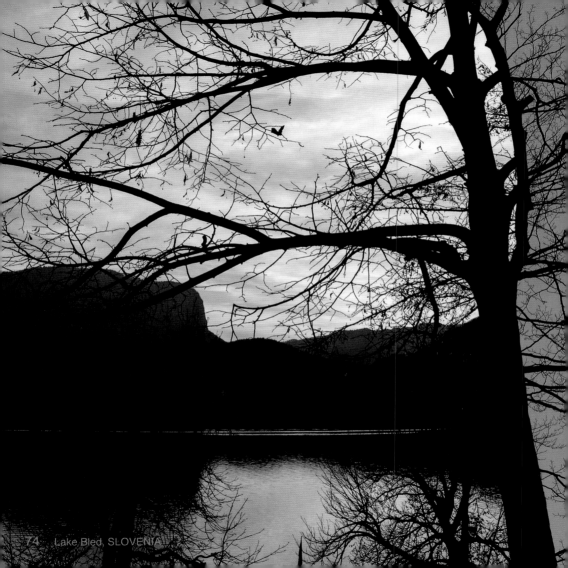

YESTERDAY IS HISTORY

TOMORROW IS A MYSTERY

TODAY IS A GIFT

THAT'S WHY IT'S CALLED THE PRESENT

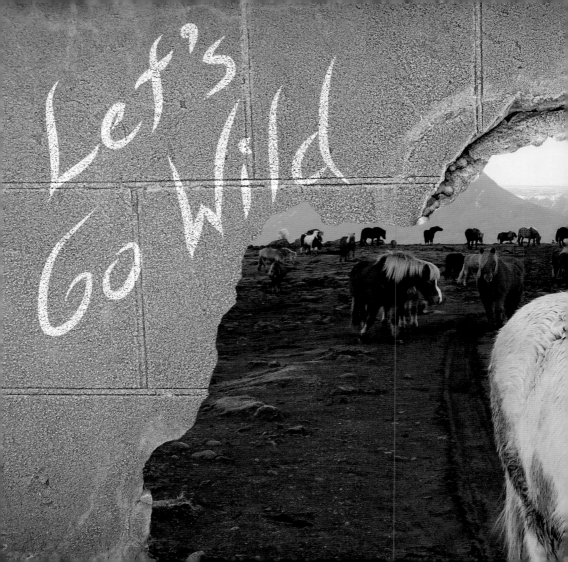

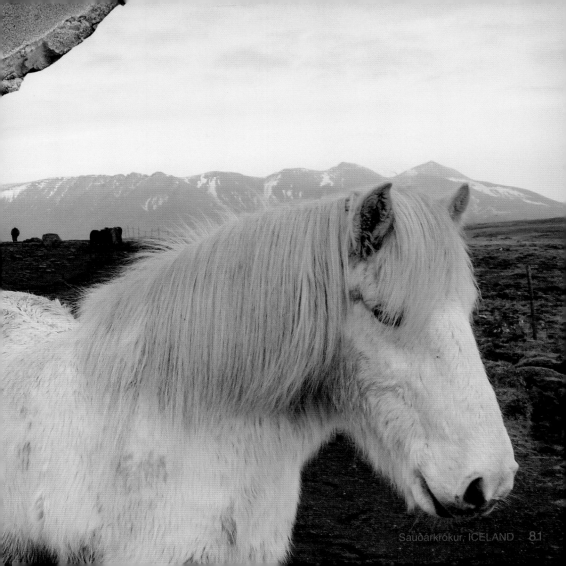

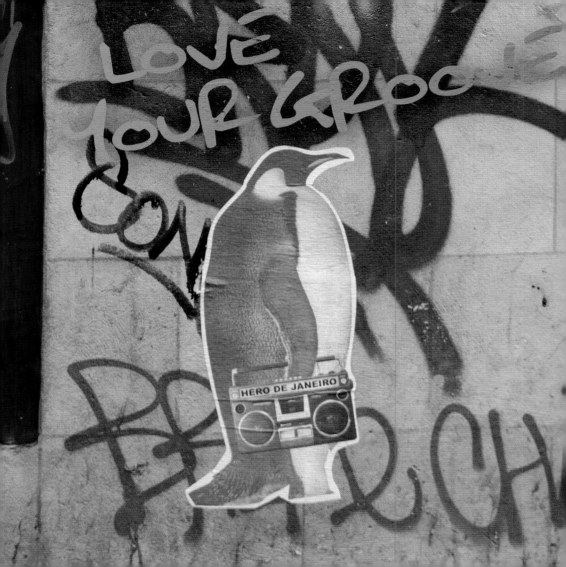

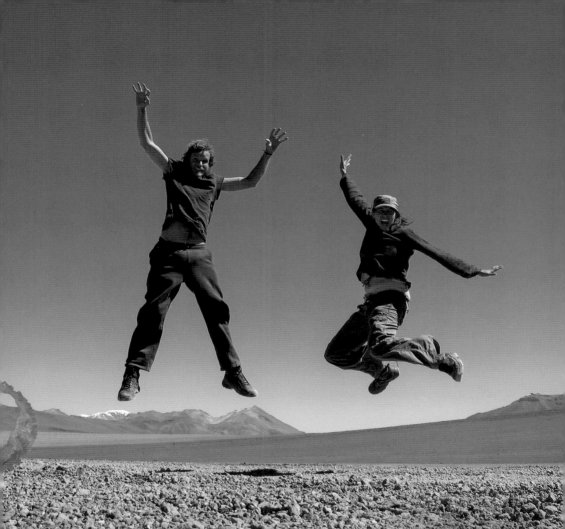

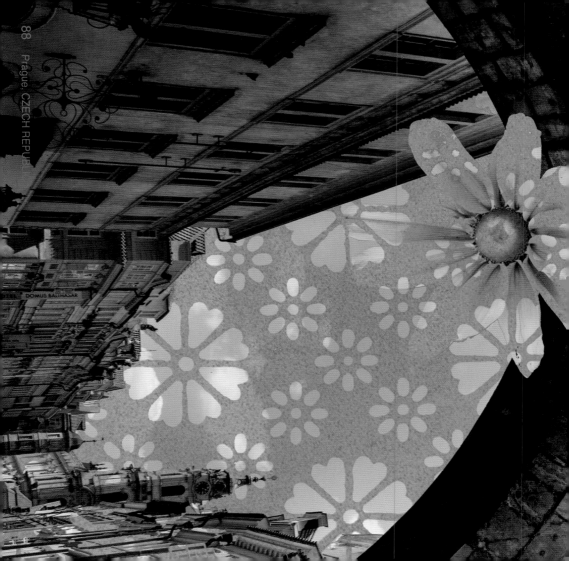

DOMUS BALTHASAR

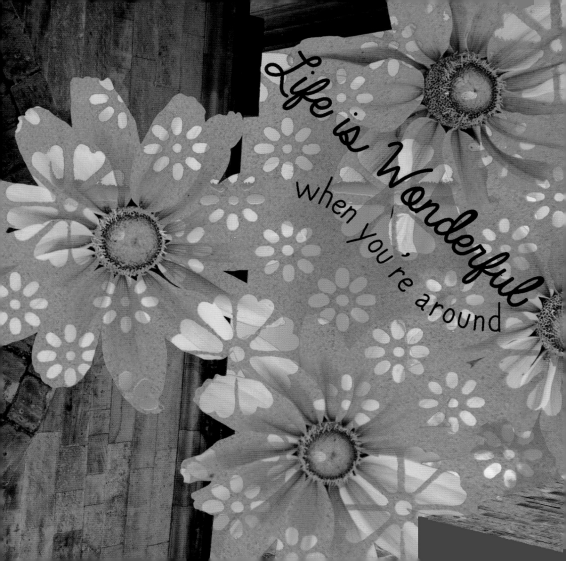

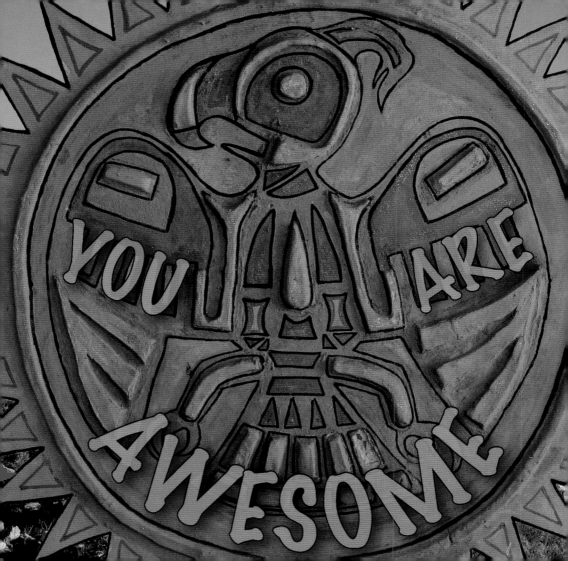

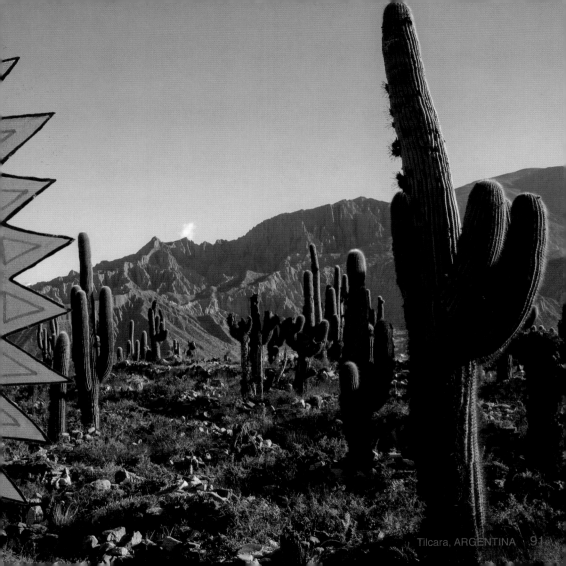

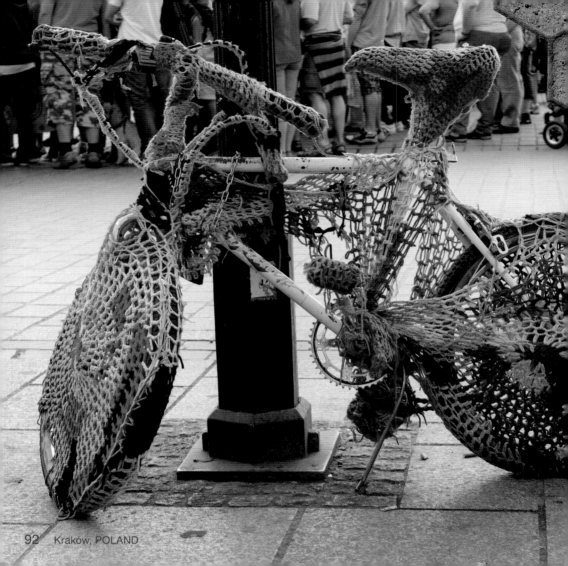

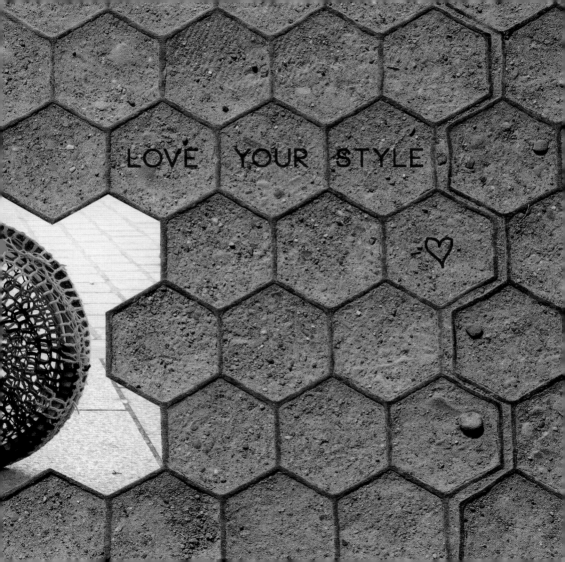

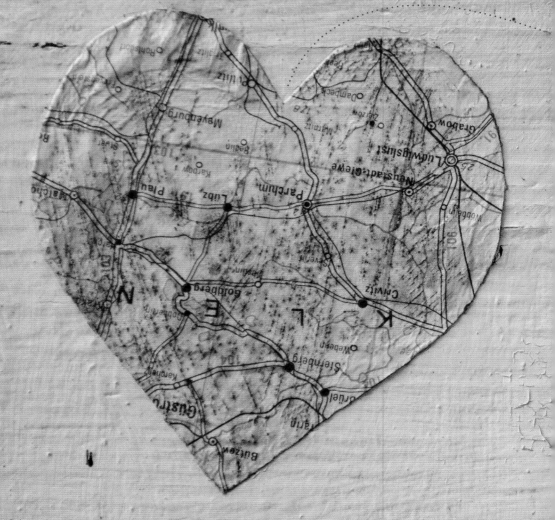

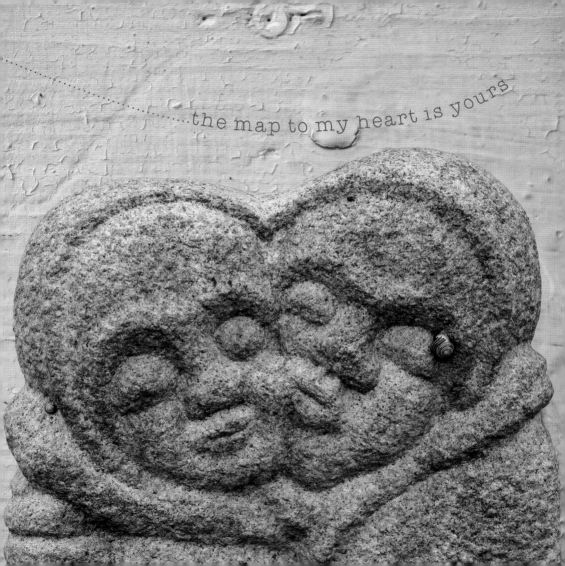
the map to my heart is yours

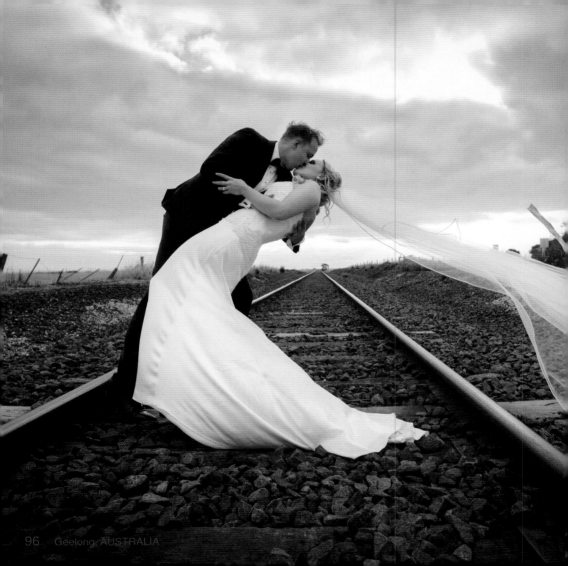

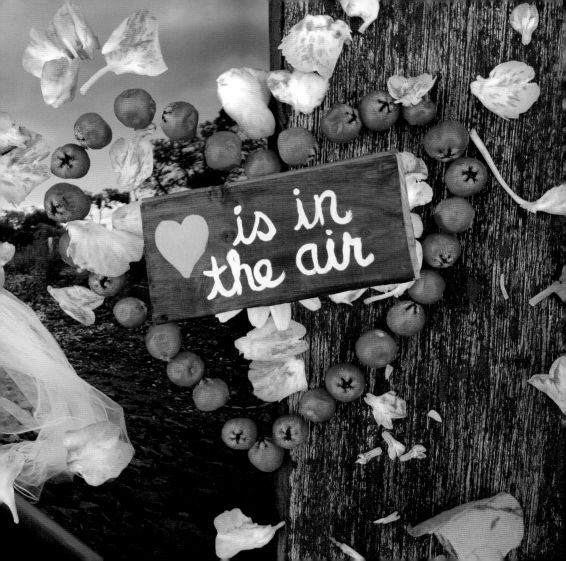

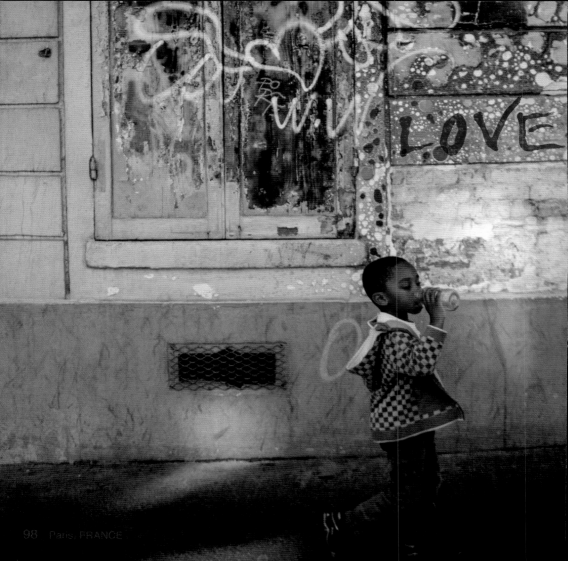

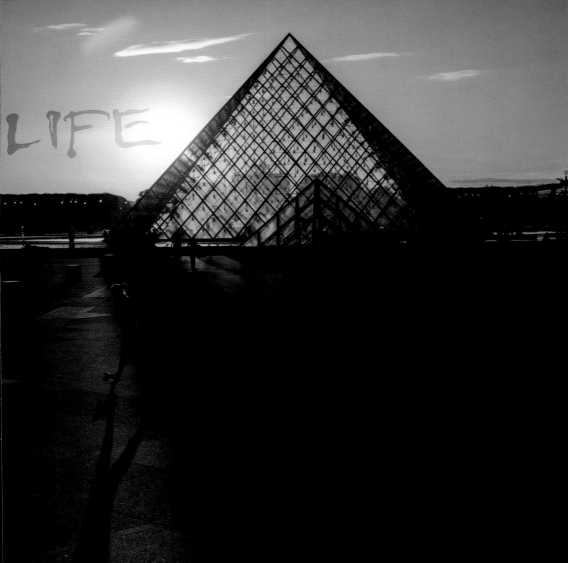

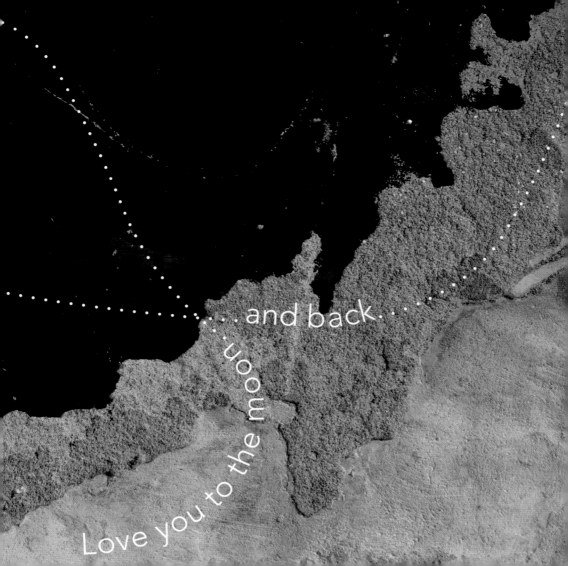

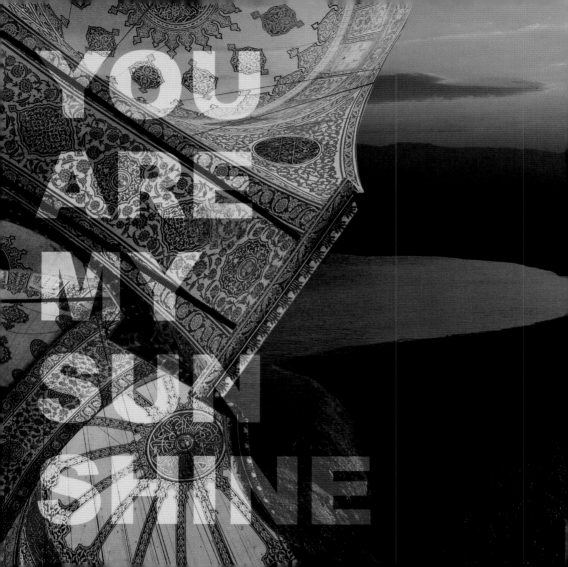

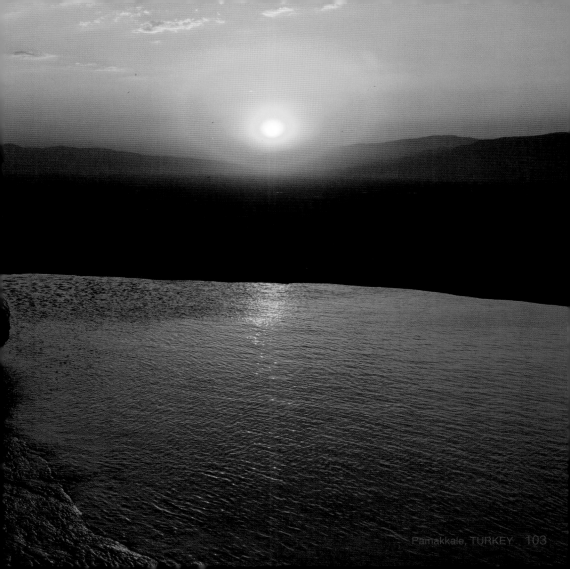

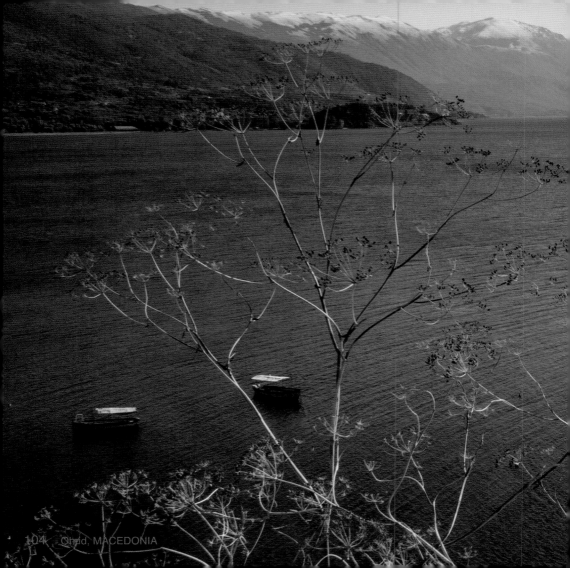

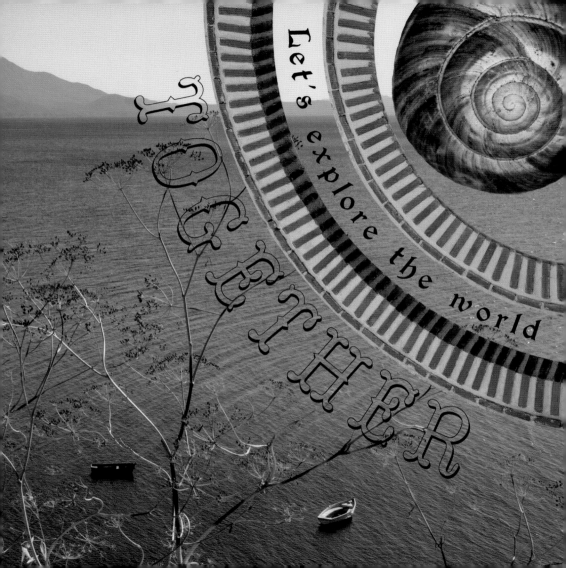

Let's explore the world

TOGETHER

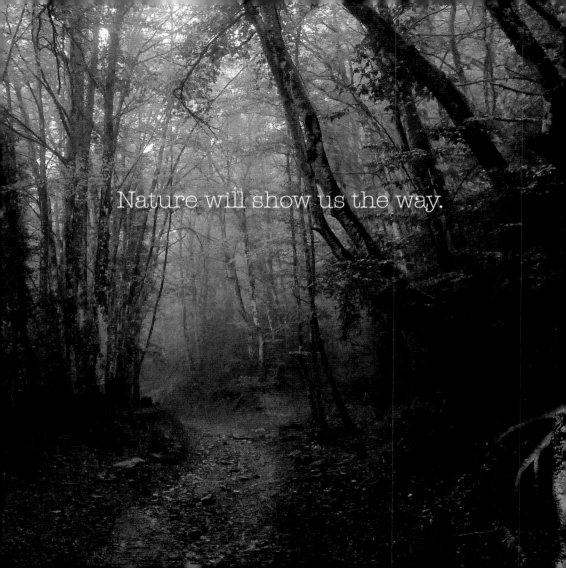
Nature will show us the way.

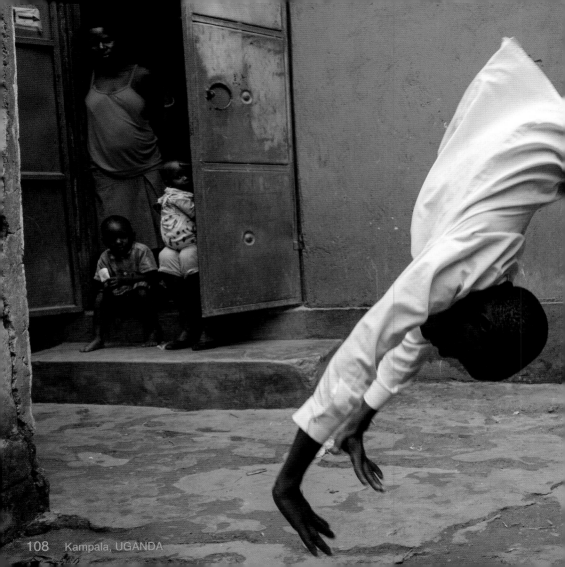

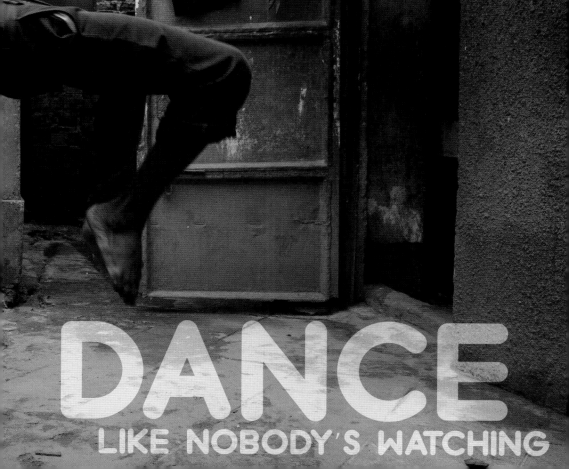

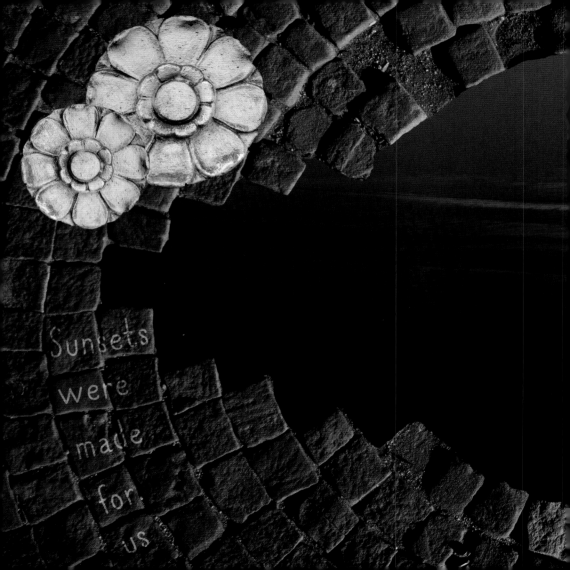

Sunsets
were
made
for
us

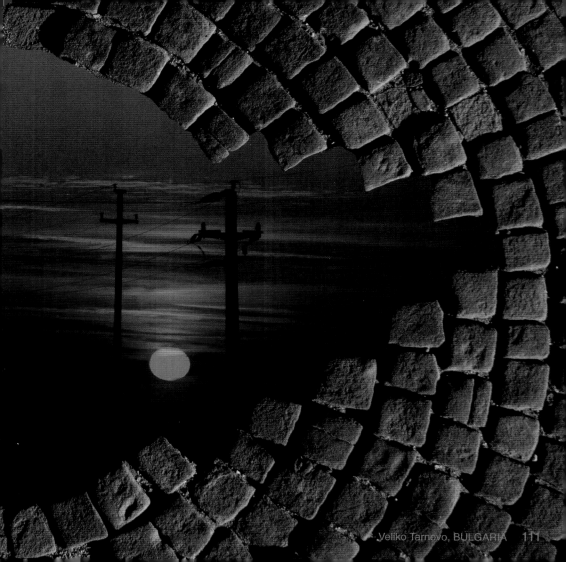

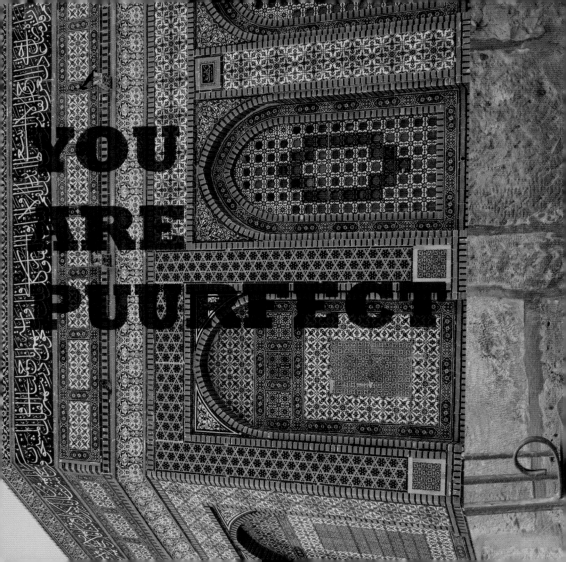

YOU ARE PUURFECT

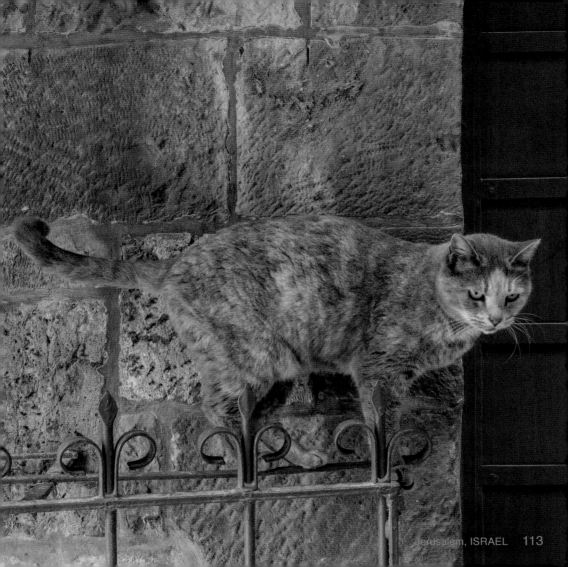

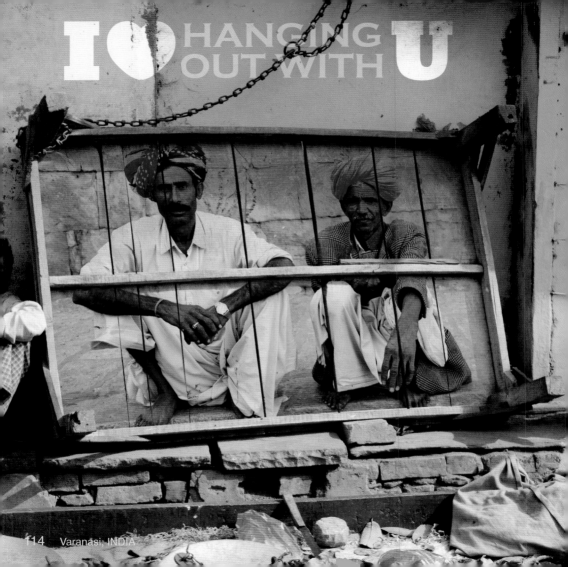

I ♥ HANGING OUT WITH U

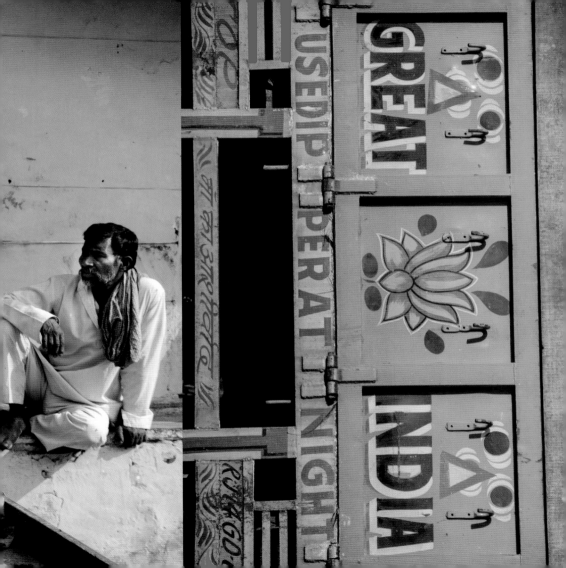

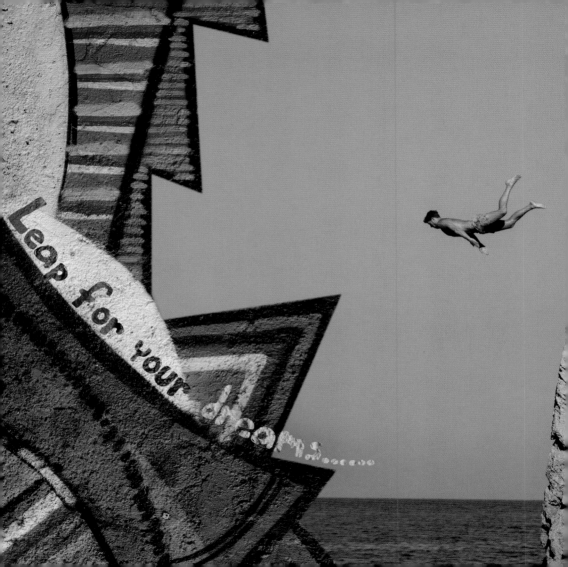

Leap for your dreams......

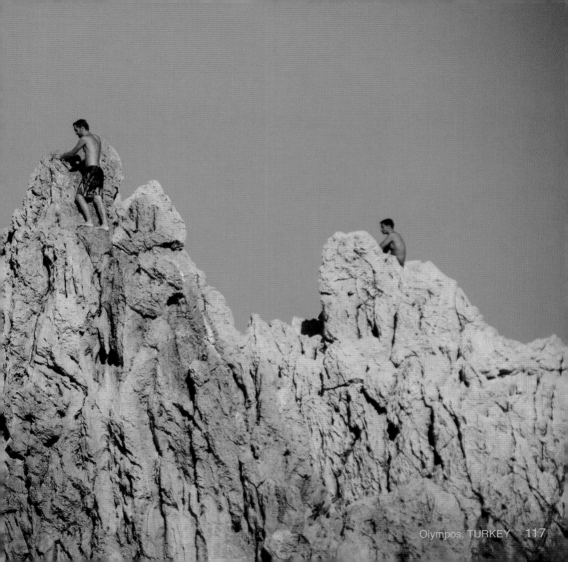

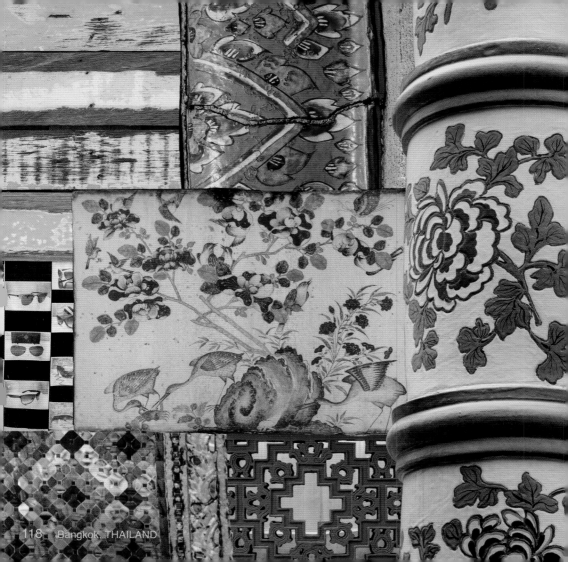

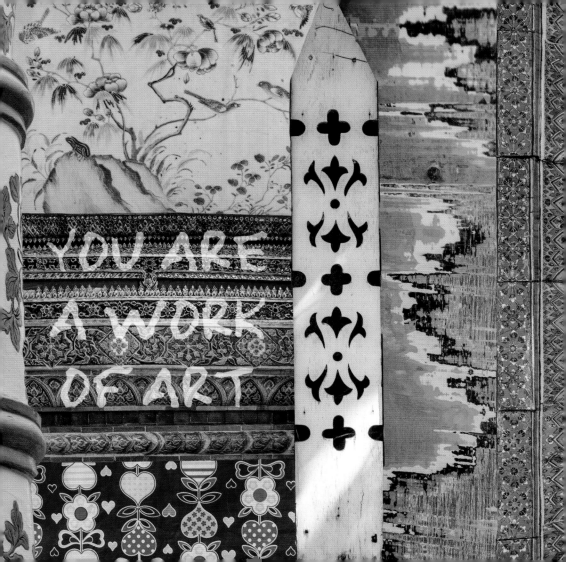

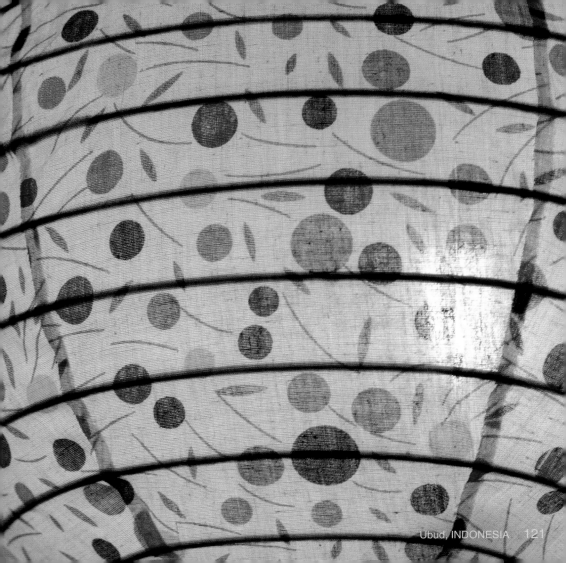

Ubud, INDONESIA 121

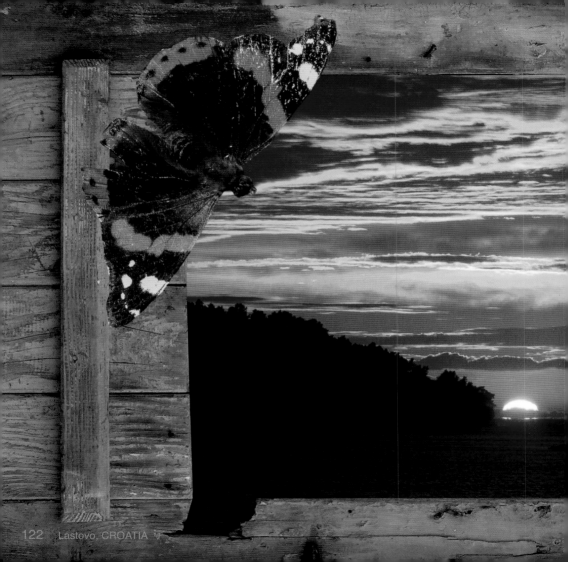

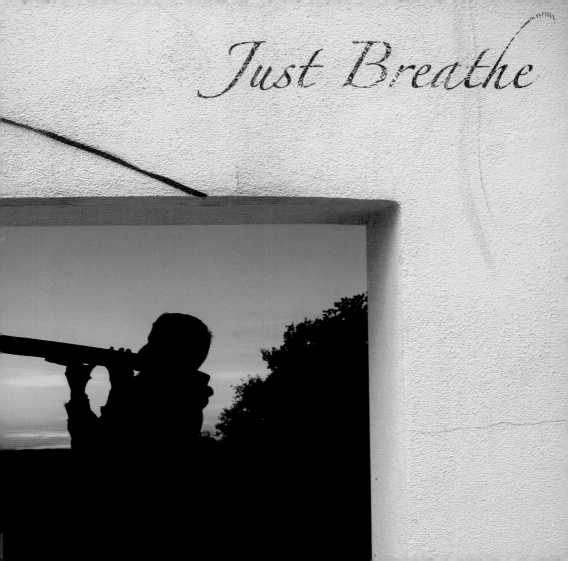

Just Breathe

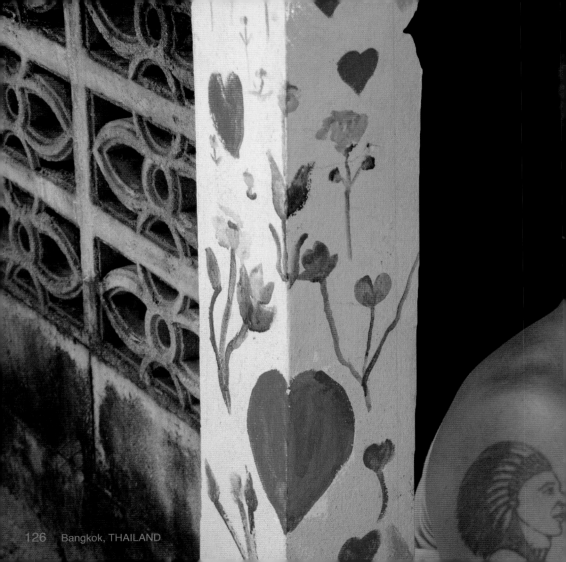

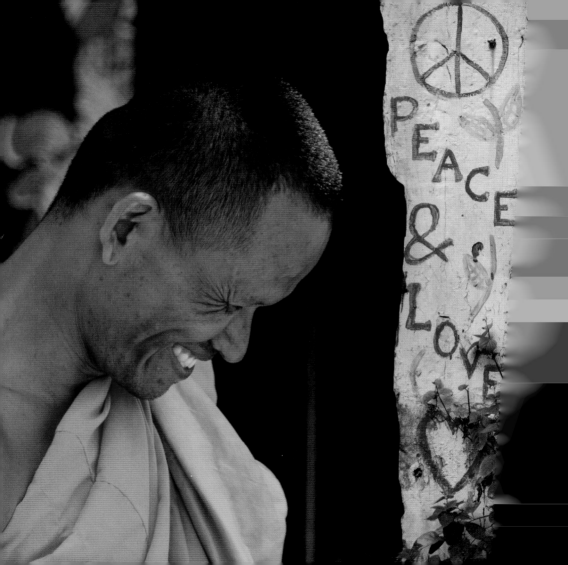

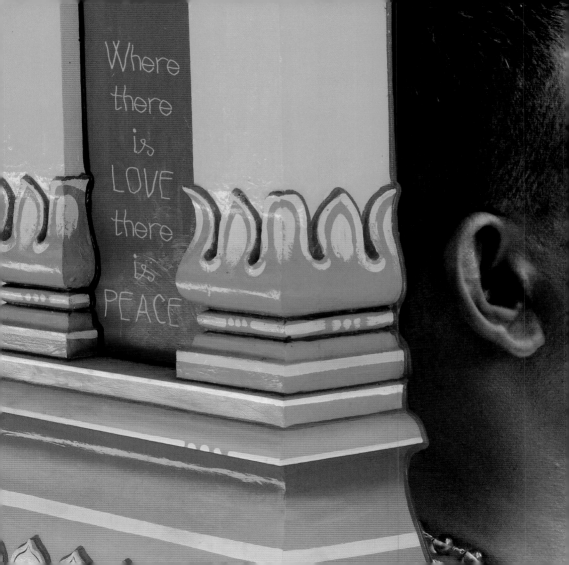

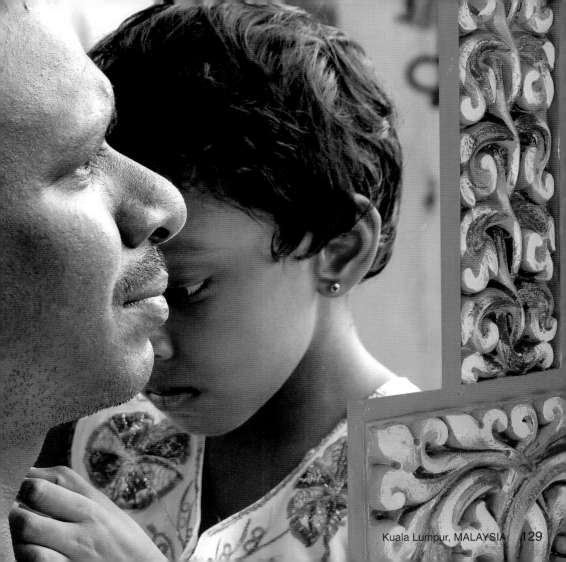

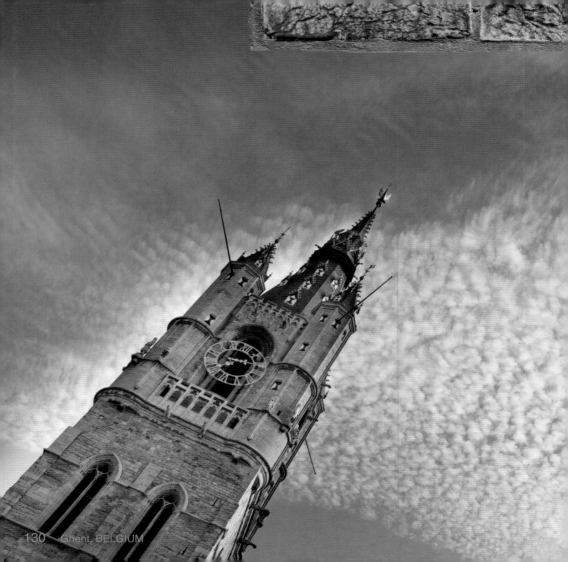

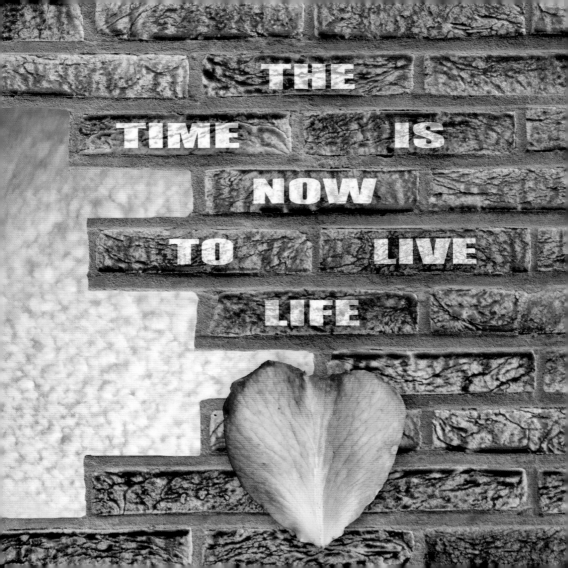

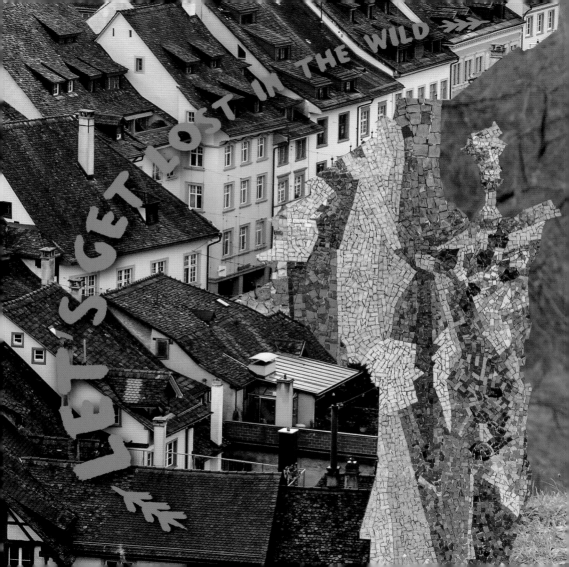

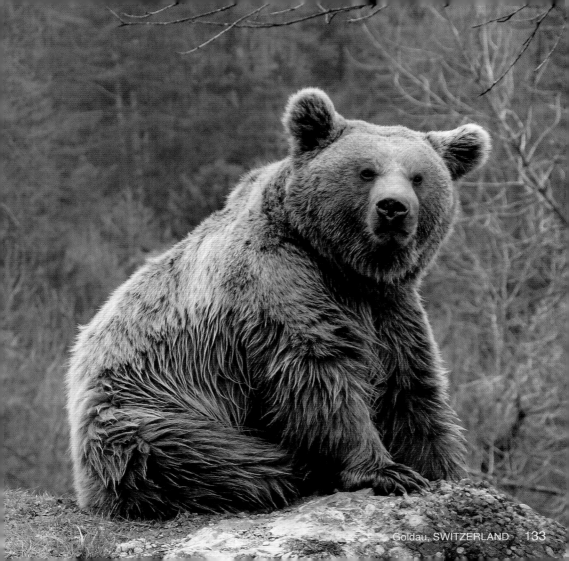

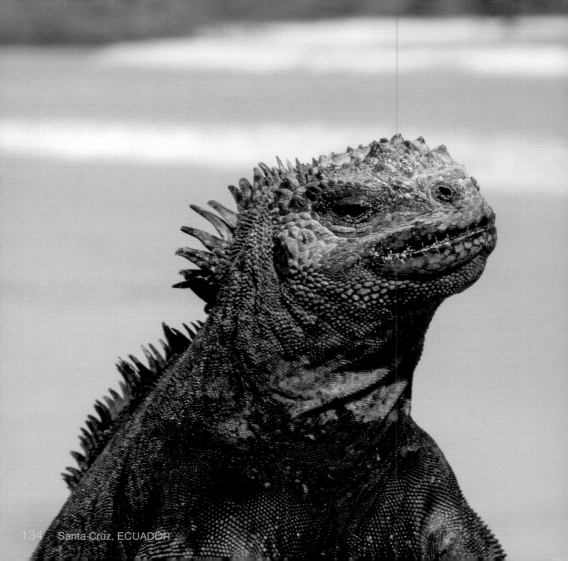

THANK YOU FOR

ALWAYS

LISTENING TO ME

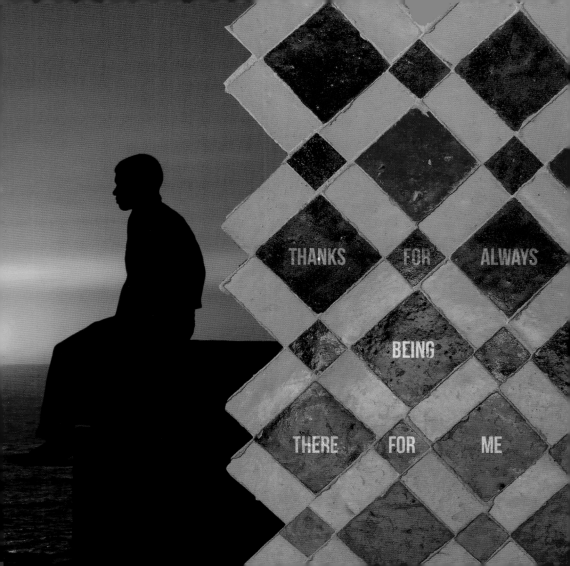

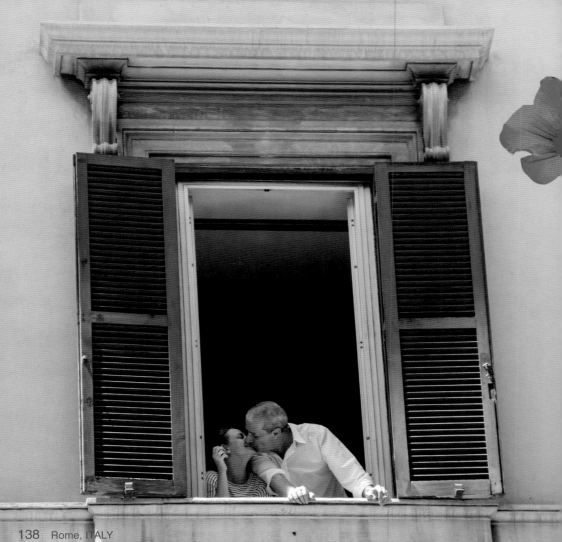

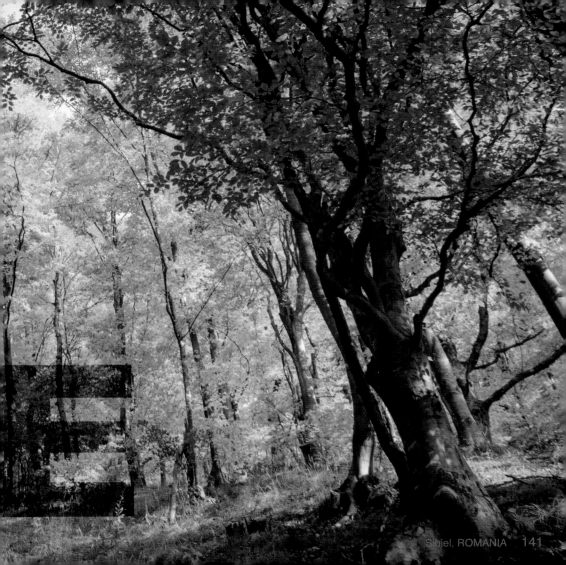

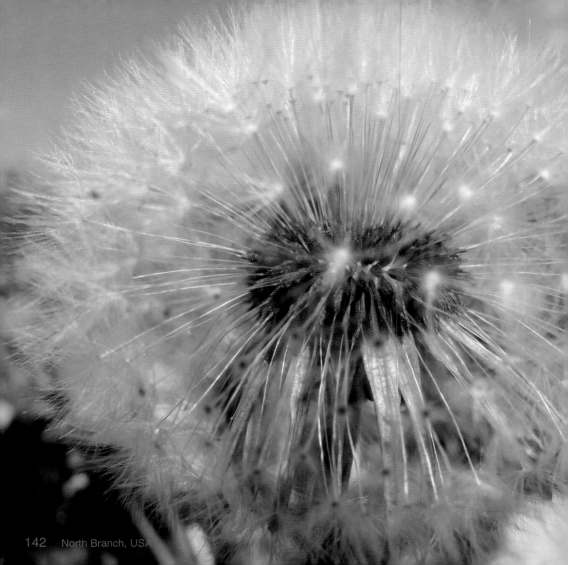

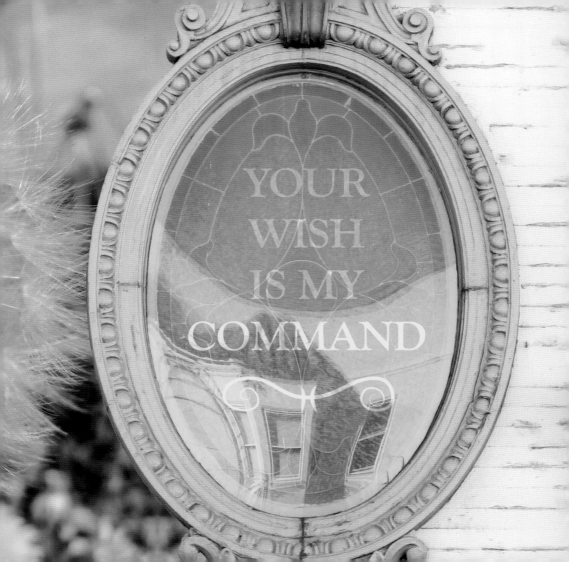

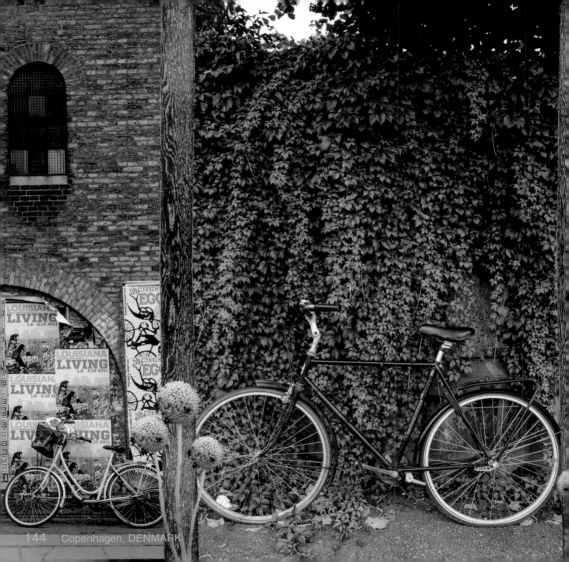

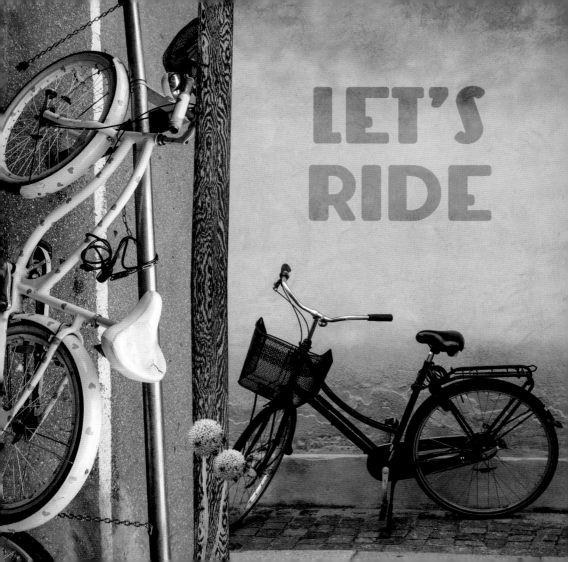

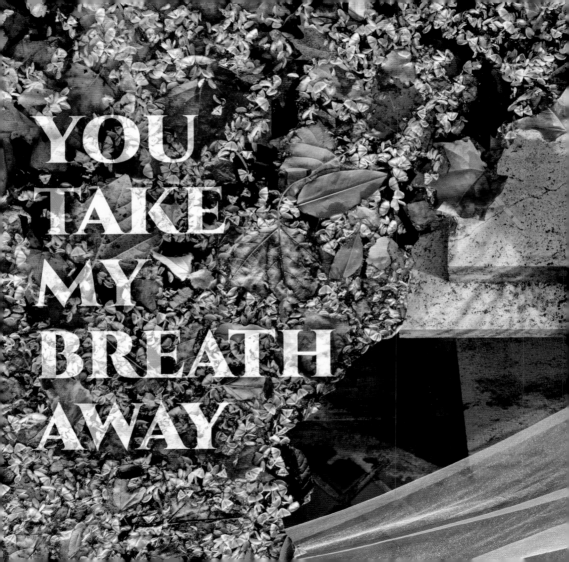

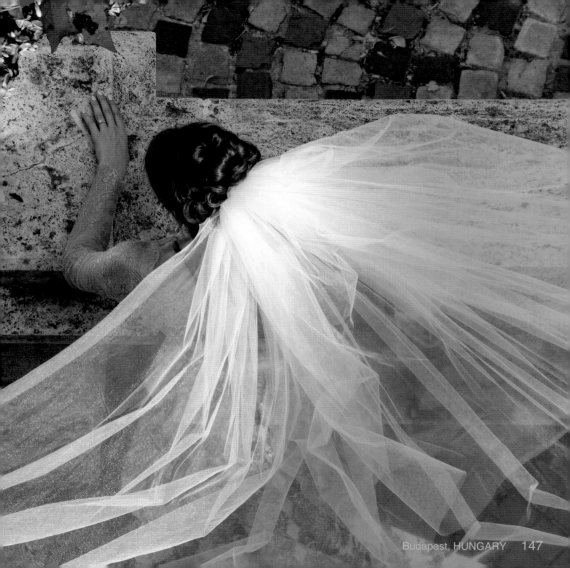

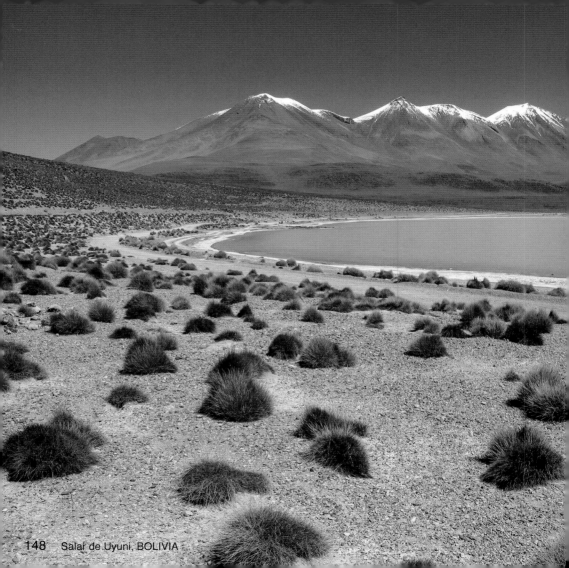

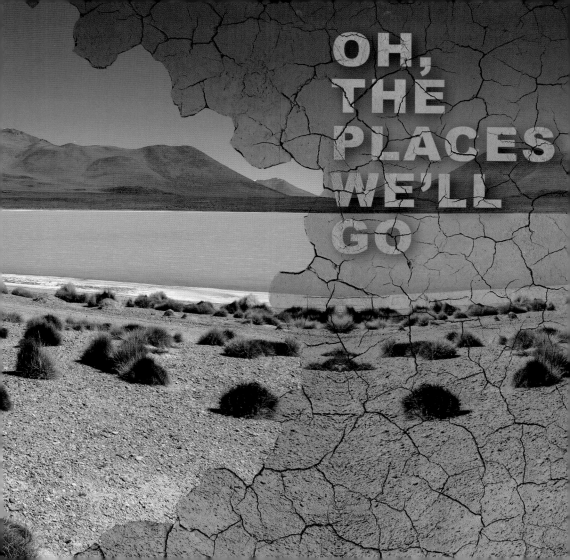

FROM DAWN

I'LL BE THINKING

UNTIL DUSK

ABOUT YOU

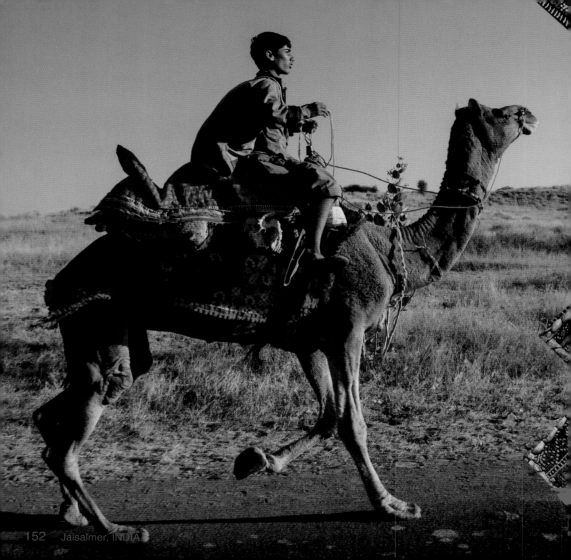

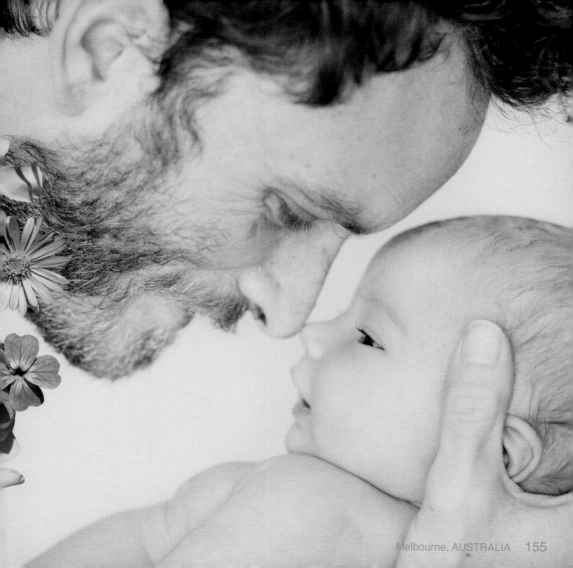

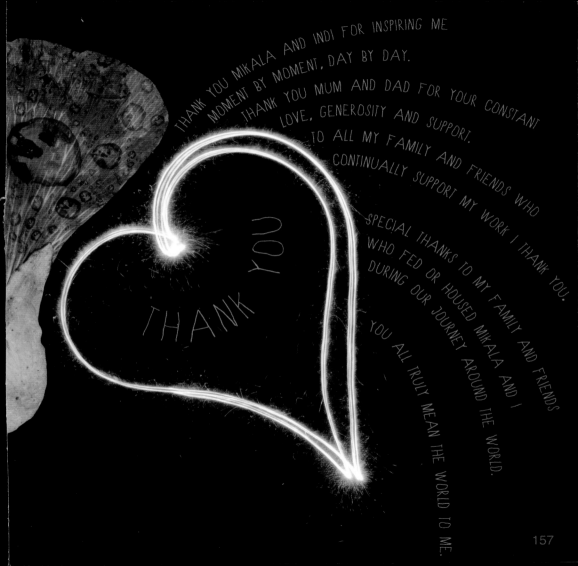

THANK YOU MIKALA AND INDI FOR INSPIRING ME MOMENT BY MOMENT, DAY BY DAY. THANK YOU MUM AND DAD FOR YOUR CONSTANT LOVE, GENEROSITY AND SUPPORT. TO ALL MY FAMILY AND FRIENDS WHO CONTINUALLY SUPPORT MY WORK I THANK YOU. SPECIAL THANKS TO MY FAMILY AND FRIENDS WHO FED OR HOUSED MIKALA AND I DURING OUR JOURNEY AROUND THE WORLD. YOU ALL TRULY MEAN THE WORLD TO ME.

THANK YOU

JESSE HUNTER

@jessehunter_author

facebook.com/alltheloveintheworldthebook

@jessehunterauth

OTHER BOOKS BY JESSE HUNTER

@alltheloveintheworldthebook

facebook.com/alltheloveintheworldthebook

@allthehappinessintheworld

facebook.com/allthehappinessintheworldthebook

@allthecatsintheworldthebook

facebook.com/allthecatsintheworldthebook

Always know that you mean the world to someone.

- Jesse Hunter